Reimagining
Captain Cook
Pacific
perspectives

Julie Adams
Lissant Bolton
Theano Guillaume-Jaillet
Mary McMahon
Gaye Sculthorpe

The British Museum

Acknowledgements

The authors would like to acknowledge the lenders and others for advice and assistance in the creation of the exhibition and publication: the Royal Collection, Nicholas Thomas, Annie E Coombes, Laura Bradshaw, Jeremy Coote, Rachael Lee, April Youngblood and Jeremy Uden. We would particularly like to thank the supporters of this publication, Stephen and Julie Fitzgerald, for their continued support. Special thanks also go to the staff involved in creating the exhibition, as well as to the British Museum photographers who worked tirelessly to produce the images for this publication. Thanks also to Bethany Holmes and Alice Nightingale for their editorial input, Beata Kibil for the production of the book and Will Webb for the design.

This publication accompanies the exhibition
Reimagining Captain Cook: Pacific perspectives
at the British Museum from 24 November 2018 to 4 August 2019.

Supported by Stephen and Julie Fitzgerald

This exhibition at the British Museum has been made possible by the provision of insurance through the Government Indemnity Scheme. The British Museum would like to thank the Department for Digital, Culture, Media and Sport and Arts Council England for providing and arranging this indemnity.

First published in the United Kingdom in 2019 by
The British Museum Press
A division of The British Museum Company Ltd
The British Museum Company Ltd, Great Russell Street, London WC1B 3QQ
britishmuseum.org/publishing

A catalogue record for this book is available from the British Library

ISBN 978 0 7141 5215 8

Designed by Will Webb Design
Printed and bound in Slovenia by GPS Group

Front cover:
Cookie in the Cook Islands
Michel Tuffery (born 1966),
Aotearoa New Zealand, 2008
Acrylic on canvas; 505 x 760 mm
The British Museum

Back cover: Fan
Marques Hanalei Marzan
(born 1979)
O'ahu, Hawaii, 2018
Pandanus leaves, coir;
390 x 318 mm
The British Museum

Contents

Acknowledgements 2

Maps 4

Introduction 6

James Cook's Pacific Voyages 10

Tahiti 16

Aotearoa New Zealand 30

Australia 36

Vanuatu 44

New Caledonia 48

Hawaii 52

Britain 58

Reading list 64

Illustration credits 64

Maps

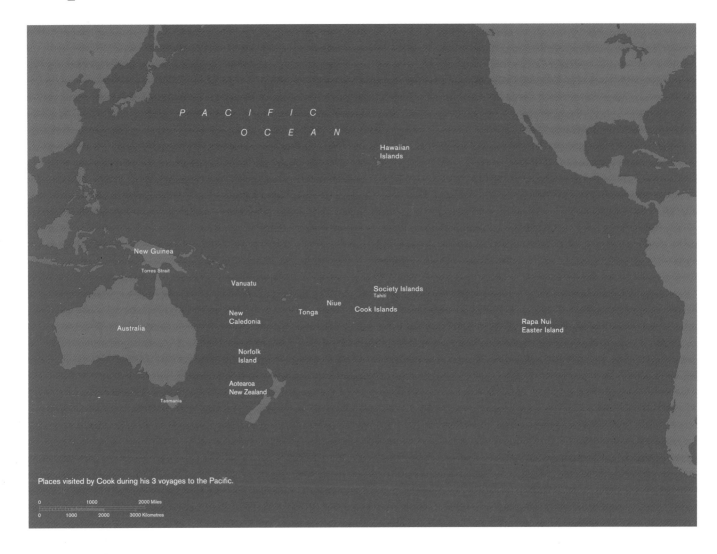

Places visited by Cook during his 3 voyages to the Pacific.

| 0 | 1000 | | 2000 Miles |
| 0 | 1000 | 2000 | 3000 Kilometres |

Map 1: Map of the Pacific Ocean identifying the places Cook visited during his voyages that form the focus of this book.

Map 2: Map showing the routes taken by Cook's ships on each of his three voyages.

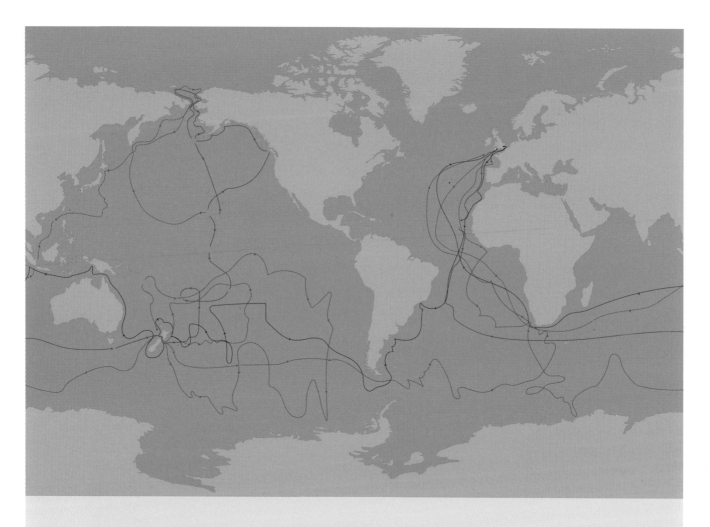

— **First Pacific voyage (1768–71) on HMB** *Endeavour*,
including Tahiti, Aotearoa New Zealand, Australia

— **Second Pacific voyage (1772–5) on HMS** *Resolution* **and HMS** *Adventure*,
including Tahiti, Tasmania, Aotearoa New Zealand, Tonga, Rapa Nui Easter Island,
Niue, Vanuatu, New Caledonia, Norfolk Island

— **Third Pacific voyage (1776–80) on HMS** *Resolution* **and HMS** *Discovery*,
including Tahiti, Tasmania, Aotearoa New Zealand, Tonga, Hawaiian Islands

········ **Return journey to London after Cook's death on the island of Hawaii, 1779**

Introduction

This book – and the exhibition it accompanies – considers some of the ways in which the figure of James Cook has been interpreted through time and in different places. Incorporating Pacific perspectives in the form of contemporary artworks made by artists from the region, it offers a reimagining of Cook and the legacy of his extraordinary voyages.

Captain James Cook (1728–79) was a navigator and explorer whose voyages in the Pacific focused on the scientific documentation of discoveries new to Europe – thereby making him a hero of the Enlightenment. Cook himself made charts and wrote detailed journals, while the scientists, artists and scholars who accompanied him described and compiled collections of the things they encountered. Almost everyone on board Cook's ships collected objects during their travels. Although sailors often traded away what they had picked up in one place upon arrival at the next, it is the rich legacy of all these objects, drawings and charts that have made the voyages famous.

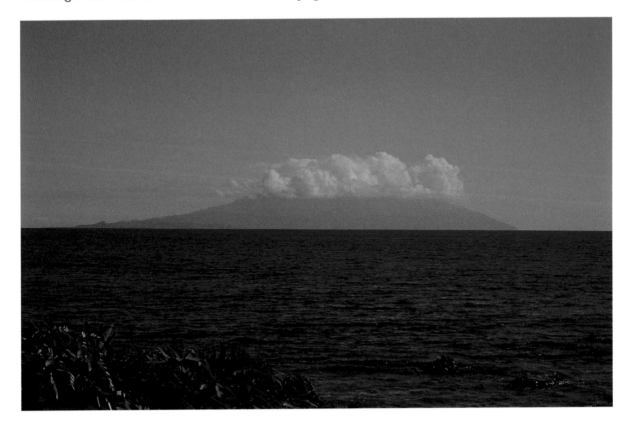

If for two centuries narratives of Cook's voyages made him a hero in Europe, in recent years a more critical and nuanced approach has begun to challenge such over-simplifications. The rhetoric of decolonisation, and that of indigenous rights, has meant that Cook has now become a way of speaking about first European arrivals, even in parts of the Pacific that he never visited. In Australia and Aotearoa New Zealand especially, he is often seen as being responsible for bringing about the British appropriation of land and the subsequent colonial state. At the same time, Pacific Islanders are shaping new perspectives of the events of his voyages, providing fresh insights into what was happening in the places he visited at the time and offering compelling engagements with the legacies of these unequal, uneasy encounters.

The Pacific Discovered

Although he has come to represent the idea of 'discovery', James Cook was not the first European to sail the Pacific Ocean – and certainly not the first person to do so. It was at least 60,000 years ago that Australia and the island of New Guinea – at the time joined as one continent – were first settled. Successive voyages by people coming from islands to the northwest reached the northern and western shores of the continent and rapidly spread right across it. People then reached the Solomon Islands, northeast of New Guinea, about 30,000 years later. After that there was another long pause until about 3,500 years ago, when sailing canoes first made the journey out of sight of land to Santa Cruz, from there gradually exploring the ocean, settling islands now in New Caledonia, Vanuatu, Fiji, Tonga and Samoa as they went. Aotearoa New Zealand was the last to be settled, about 1,200 years ago.

Using double-hulled sailing canoes, and techniques of navigation based on observation of the stars and of the ocean itself – of currents, winds, and birds – the earliest explorers of the Pacific seem to have been traders. Sailing further and further in search of new resources and materials, they initially made settlements that perched on the rim of islands. Only later, it seems, did they become established in those islands. Gradually these long-haul voyages became a thing of the past, although ocean-sailing canoes were still plying the waters within and between nearby island groups when Europeans first reached the region.

The earliest European explorers in the Pacific sailed mainly across the northern reaches of the ocean. Ferdinand Magellan (1480–1521) journeyed west to east across the northern Pacific in 1520–1, almost 250 years before Cook's first voyage. Exploring under the Spanish flag, he missed nearly every inhabited island in the ocean (except for the southern Marianas), until he reached the Philippines. By 1565, the Spanish had learned to make use of the northern Pacific westerly winds, which enabled their galleons to conduct regular voyages from Manila in the Philippines to Acapulco in Mexico. Again it was a route that inadvertently avoided the islands of the Pacific, although it is thought that at least one ship may have been wrecked in Hawaii. It was not until 1568 that the Spanish navigator Alvaro de Mendaña (1542–95) discovered the Solomon Islands, and in 1595, on a second expedition, that he reached the Marquesas and touched on a number of other island groups. His chief pilot on the second voyage, Fernandez De Quiros (1563–1614), then went on to lead an expedition that in 1606 reached what is now northern Vanuatu. De Quiros attempted to establish a settlement there, but abandoned it after only three weeks.

Ambae, Vanuatu
Cook sailed this stretch of water as he entered the Vanuatu archipelago in 1774
Photograph by L. Bolton, 1999

And so it continued: a series of voyages, each building on the others, gradually extending Europe's knowledge of the Pacific. The Dutch reached Australia and Aotearoa New Zealand in the seventeenth century, and more islands were contacted in the eighteenth century. Of these, the one that most fired European imaginations was Tahiti, which was reached in June 1767 by an English expedition led by Samuel Wallis (1728–95) and in April the following year by an expedition led by Frenchman Louis-Antoine de Bougainville (1729–1811). Both were equally entranced by their encounters.

Despite all of these voyages, European knowledge of the Pacific – as historian John Beaglehole observed in the twentieth century – lacked any real definition: a number of island groups could be put on the map, but without great accuracy. The question that had driven a great deal of European exploration – whether there was a great southern continent – also remained unanswered.

It was as the latest in a series of voyagers, therefore, that Cook first departed the shores of Britain in 1768. He took with him accounts of many of the earlier voyages and made references to them in his own journals. He set off with two goals in mind: to observe from a vantage point in the south Pacific the transit of Venus across the sun, and to effect, as his instructions from the Admiralty put it, the 'discovery of the Southern Continent so often mentioned'.

The question about the existence of a great southern continent was not answered during Cook's first voyage; his second voyage (1772–5) achieved that goal. The third voyage (1776–80) had the objective of finding a northwest passage back to the Atlantic from the Pacific and ended for Cook himself on 14 February 1797 when he died in a scuffle on a beach in Kealakekua Bay, Hawaii.

Pacific Perspectives

Cook's three voyages, the first as a lieutenant and thereafter as a captain, provided important insights into the societies that he encountered in the Pacific. Over time these insights – and especially the collections made during the voyages – have gone on to gain new significance, revealing aspects of life in the Pacific, some of which have changed substantially in the intervening years. Today, two and a half centuries after Cook's first journey, it is also possible to bring a new perspective to bear on those encounters: the perspective 'from the beach', as Australian historian Greg Dening so aptly phrased it.

In a few cases, perspectives on an encounter with Cook derive from details passed through the generations in that place. Members of the Ngati Oneone *iwi* (tribe) in what is now Gisborne, Aotearoa New Zealand, are able to recount vividly the events of Cook's first landing there in October 1769, and to give a name – Te Maro – to the man shot dead within the first hour of that encounter. Strikingly, when viewed from this Māori perspective, the key character in the story is not Cook but a Tahitian called Tupaia (1725–70), who had joined the expedition a couple of months earlier at Tahiti, before it sailed south. The day after the murder, when a large group of Māori gathered to challenge the invaders, it was Tupaia who addressed them, and made himself well enough understood to become a mediator between Māori and the explorers. When Cook returned to Aotearoa New Zealand on his second Pacific voyage, Māori asked after Tupaia and wept when they learned of his death. Today, when Māori remember these first encounters, they think of the *Endeavour* not as Cook's ship but as Tupaia's.

In other parts of the Pacific, memories of the arrival of Cook's ships – and of the impact of those initial encounters – have not survived the passage of time. Nonetheless, people in the region can offer a different way of interpreting the events recorded in the voyage journals by putting forward their own cultural perspectives. When Europeans reflect on the stories of the voyages and the peoples encountered, they sometimes fail to consider that Cook's landings on shores across the Pacific always occurred in specific local historical circumstances.

The significance of local context has been much debated in the analysis of Cook's third voyage, specifically in relation to his encounters on the Hawaiian Islands and to his killing on the shore at Kealakekua Bay. Having arrived in the Bay in January 1779, at the time of a religious festival celebrating a god of peace and productivity called Lono, it is often argued that Cook himself was regarded as a temporary incarnation of the god. In February the ships set sail again to survey the coast, but a broken mast sent them back to Kealakekua Bay just a few days later. By then, the festival was over and Cook's reappearance was ill-timed both in a religious and probably also a political sense. The expedition received a very different reception – one that led, one way or another, to Cook's death.

History is a matter of perspective. Even as they occurred, the events of Cook's voyages were seen differently from the viewpoint of those on the ship and those on the beach. And the subsequent understanding of these events is subject to the forever changing perspective afforded by the vantage point of the present. Cook has come to represent European arrival across the Pacific in general – and it is certainly true that the accuracy of his maps enabled that arrival to occur. As a result, he is also often held to be personally responsible for all the troubles of colonialism that followed.

Indigenous artists from across the Pacific region continue to make works that reflect upon the momentous impact and legacy of those voyages. As Vincent Namatjira (born 1983), a contemporary Australian artist, has commented 'after Cook everything was between all of us'.

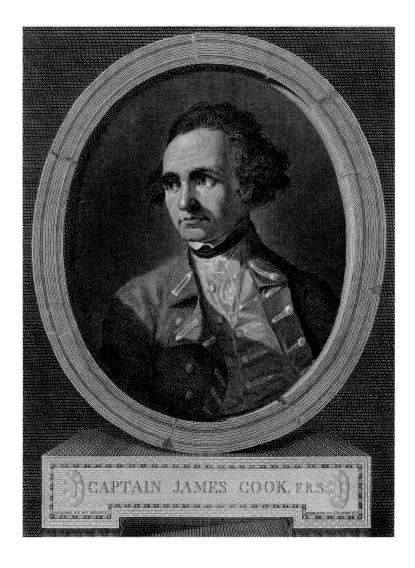

James Cook's Pacific Voyages

It was over 250 years ago that James Cook set out on the first of three expeditions to the Pacific Ocean. He visited many lands new to Europeans and the accounts that he wrote of his voyages were widely read throughout Europe. After he died on his third voyage in 1779 and the account of his final expedition was published in 1784, he became a widely celebrated figure in Britain. His relentless search for knowledge and first-hand observation of the world also made him a hero of the intellectual movement known as the Enlightenment that dominated the world of ideas in Europe during the eighteenth century.

Born in North Yorkshire in 1728, Cook learnt to sail in the difficult waters between Newcastle and London. After joining the Royal Navy in 1755, he was rapidly promoted and supplemented his military training by independently developing his skills in marine surveying, mathematics and astronomy. From 1763–7, he was given the opportunity to put these skills into practice after being sent by the Admiralty to survey Newfoundland, Canada. And so it was that on his return – though still only a lieutenant – he was judged to be up to the challenge of leading the Pacific expeditions.

The official purpose of Cook's first voyage to the Pacific (1768–71) on the HMB *Endeavour* was to record the transit of Venus – a rare astronomical phenomenon during which the planet passes directly between the Earth and the Sun. Since this involved journeying to the Pacific – the last great region of the world to remain unknown to Europeans – the Admiralty also gave Cook a second unofficial mission: to look for 'the southern continent', the potentially rich landmass that many believed must exist to balance out the landmass in the northern hemisphere. After landing at Tahiti and carrying out the official purpose of the voyage, Cook therefore journeyed on to Aotearoa New Zealand and the east coast of Australia, but without gathering conclusive proof of the existence or otherwise of a greater landmass. This then became the purpose for Cook's second voyage from 1772–5 – his first as captain.

It was purportedly to return Omai (1751–80), a young Tahitian man who had joined the second expedition, to his home that Cook's third and final voyage was undertaken from 1776–80. However, the Admiralty had in fact instructed the veteran captain to find the 'Northwest Passage' – a navigable route that various rival nations hoped could be found between the Atlantic and the Pacific around North America. It was on this journey that Cook became the first European to set foot on the Hawaiian Archipelago.

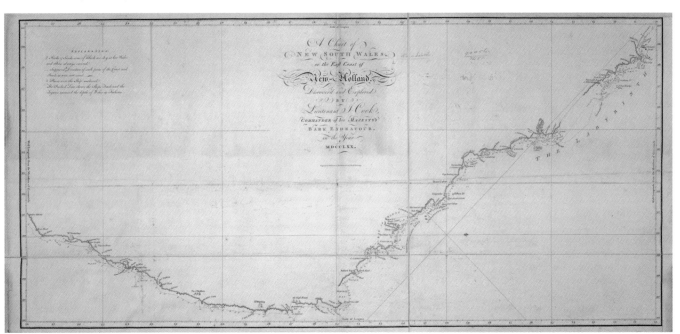

A Chart of New South Wales
or the East Coast of New Holland
After James Cook, published in the first voyage account, 1773
Drawing on paper; 1020 x 570 mm
The British Library

War club, possibly collected on Cook's third voyage
Tonga, 1700–1800
Wooden club of lozenge section with geometrical and zoomorphic ornament;
915 x 113 mm
The British Museum

Poe-bird New Zee-land
William Strahan and Thomas Cadell, after John Webber (1751–93), 1777
Engraving; 305 x 235 mm
The British Museum

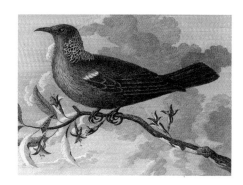

Expeditions like this were about locating resources, building alliances, finding trade routes and gathering knowledge. Cook's team therefore collected and recorded numerous specimens of animals and plants, which were studied and categorized by Europeans as 'new' discoveries. The truth, of course, was that many specimens had been collected using the assistance of Islanders, for whom they were in no sense 'new'. The team also exchanged, took or were given objects from the different Pacific communities they encountered, sometimes trading away at one island what they had acquired on the last one they had visited. Although some of the first encounters between Europeans and Pacific Islanders passed quite peacefully, others included bloody confrontation, political disruption and the spread of new diseases, especially venereal disease.

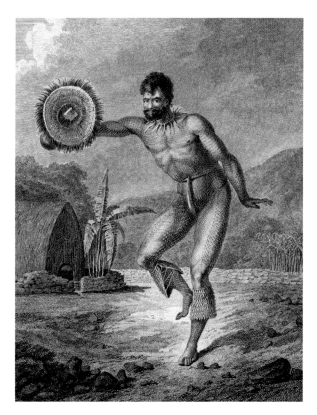

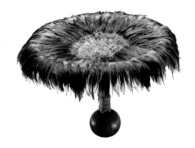

Dance rattle, collected on Cook's third voyage
Hawaii, 1700–80
Gourd, wood, palm leaf, seeds, pearl-shell, *'iwi* feathers and skin, and domestic fowl feathers;
Diam. 500 mm
The British Museum

A Man of the Sandwich Islands, Dancing
Charles Grignion, after John Webber, 1784
Etching and engraving; 299 x 210 mm
The British Museum

Captain Cook's first voyage round the world (top left)
British Museum exhibition poster
19 July–27 October 1968

Captain Cook in the South Seas (top right)
British Museum exhibition poster
15 February 1979–29 September 1980

Reimagining Captain Cook: Pacific Perspectives (below)
British Museum exhibition poster
29 November 2018–4 August 2019

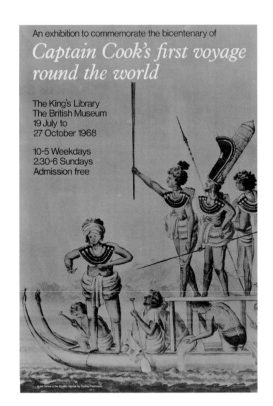

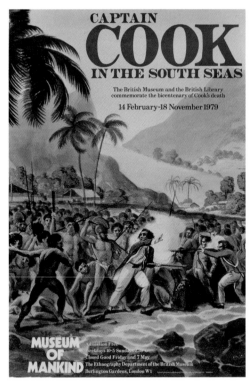

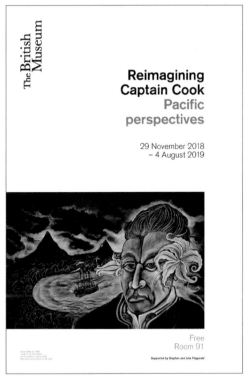

These posters are from British Museum exhibitions about Cook held in 1968, 1980 and 2018–19. The approaches and attitudes that the earlier exhibitions take to his voyages stand in contrast to those of this current publication and exhibition – most notably in the omission of non-European perspectives. Today the objects collected from Cook's voyages are scattered around the world's museums, including at the British Museum.

Cookie in the Cook Islands
Michel Tuffery (born 1966),
Aotearoa New Zealand, 2008
Acrylic on canvas; 505 x 760 mm
The British Museum

Michel Tuffery

This work is part of a series called *First Contact* in which artist Michel Tuffery retells Cook's voyages from a Polynesian perspective. In this painting, Tuffery imagines how Cook might have been altered by his encounters with the people and places of the Pacific. He depicts Cook with hibiscus flowers behind each ear and two Māori *hei-tiki* ornaments from Aotearoa New Zealand peeking out from under the lapels of his uniform. His features are distinctly Polynesian. Behind him, under a stormy sky, a European ship is seen anchored in a bay in the Cook Islands. A smaller boat has been launched from the main ship and is making its way to shore, foreshadowing the encounters that took place between Islanders and Europeans across the Pacific. In fact, Cook himself never went ashore in the Cook Islands although they were later named after him by a Russian explorer. This imagined scene reflects how Cook's legacy continues to pervade ideas about the Pacific, even in places he never visited. Tuffery traces his own ancestry from the Cook Islands, as well as from Samoa and Tahiti. When talking about the long-dead explorer, he uses the name 'Cookie' as if referring to a personal friend. The same term is also used as a nickname for a Cook Islander.

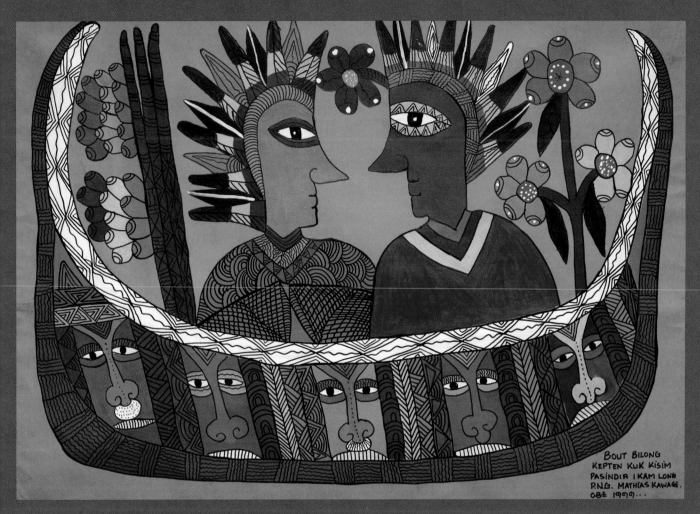

BOUT BILONG KEPTEN KUK KISIM PASINDIA I KAM LONG P.N.G. MATHIAS KAWAGE. OBE 1999...

Bout bilong Kepten Kuk kisim pasingia i kam long PNG
(Captain Cook's ship bringing passenger(s) to PNG)
Mathias Kauage (1944–2003), OBE,
Papua New Guinea, 1999
Acrylic on paper; 1040 x 800 mm
Private Collection

Mathias Kauage

Cook is now famous even in parts of the Pacific to which he never travelled. This includes Papua New Guinea (PNG), where artist Mathias Kauage created a series of images exploring the idea of Cook and his legacy. The inspiration for his work came after Kauage visited Sydney during Australia's bicentenary year in 1988 and witnessed the fanfare and debate surrounding the explorer. To Kauage, Cook stood for European arrivals of all kinds.

Tahiti

Imagining Paradise

In 1767 Captain Samuel Wallis and the crew of HMS *Dolphin* became the first Europeans to land at the islands of Tahiti. The stories they brought back to Britain of lush landscapes, strong, noble men and beguiling women painted a superficial picture of an island paradise – an image firmly embedded in the minds of the crew of Cook's *Endeavour* before their own arrival there in 1769.

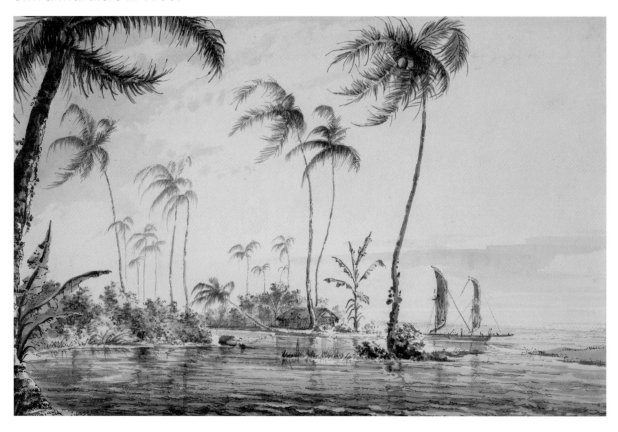

A View in the Island of Otaheite
William Hodges, 1773
Ink and watercolour on paper;
368 x 539 mm
The British Museum

This idealized vision of Tahiti was further reinforced thanks to the unprecedented decision to carry artists on Cook's three voyages of exploration. Commissioned to produce a visual record of the Pacific, its peoples and its natural environment, men such as Sydney Parkinson, William Hodges and John Webber succeeded not only in producing a rich body of work but also in creating a myth that has endured to this day. The work of Hodges, who travelled on the second voyage, was particularly influential. He created many of his romanticized views of swaying palms and tropical seas during the voyage itself before working several of them up into grand, impressive, oil paintings on his return to London. They would prove to have a lasting effect upon ideas about the Pacific.

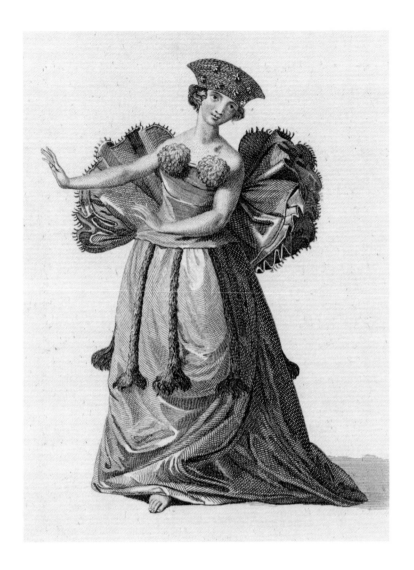

A Young Woman of
Otaheite Dancing
After John Webber, 1785
Engraving on paper;
183 x 108 mm
The British Museum

Tahitian women were central to the European imagining of the islands. Although it was recognised that some of these women enjoyed a certain status and seniority, there was little understanding of the complex and politically powerful roles that they played. What intrigued and enthralled European explorers instead was the part played by women in local customs, such as the symbolic presentation of barkcloth, which was unwrapped from the body of a young girl before being gifted to visitors. Cook's men were particularly enchanted by Tahitian dancers with their vigorous rhythmic hip movements. They wrote detailed accounts of performances in their journals and tried to capture their movements in artworks.

This representation of a Tahitian dancer is a print based on a work by John Webber, which was featured in *The Lady's Magazine* not long after the official account of the third voyage was published. Webber's European gaze has subtly altered the dancer's appearance to fit a European ideal, with her barkcloth garments more closely resembling ancient Greek robes. Her facial expression is a demure smile and her arms are shown swaying slightly, their movements elegantly mirroring each other. The fact that it was published in such a popular magazine so soon after Cook's third voyage shows how quickly the stereotype of the graceful Tahitian maiden took hold.

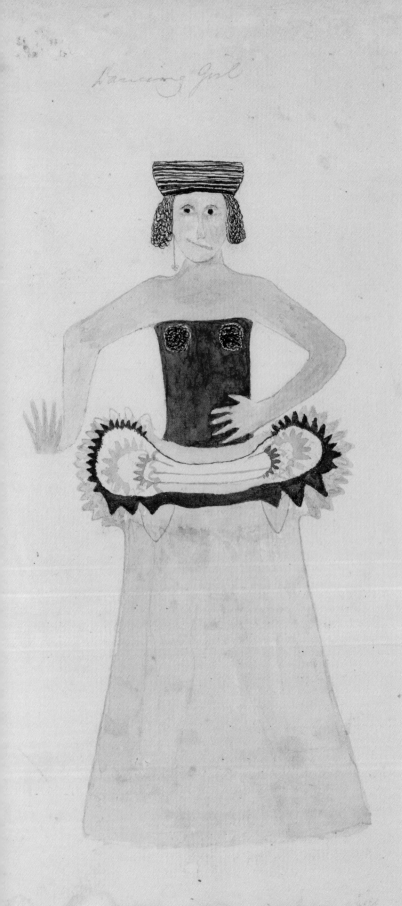

Dancing Girl

This drawing of a Tahitian dancer was made by Tupaia, the Tahitian navigator and priest who joined the crew of *Endeavour* in 1769. Given a berth previously occupied by one of the ship's artists who had died earlier in the voyage, and perhaps inspired by his new surroundings and the materials left behind in the cabin, he took up drawing. His image of a dancing girl is in stark contrast to the one made by John Webber, accurately depicting the movement of the dancer's arms, the precise placement of her hands and her distinctive facial expression – all integral aspects of Tahitian dance. The dancer is seen wearing a headdress known as a *tamau*. Painstakingly created from individual strands of plaited human hair, wound together in a loose twist, tamau were precious, highly valuable ornaments, worn by high-ranking women and dancers. Cook recorded in his journal that he punished two of his crew who had stolen such a headdress, after local people complained to him of its loss. The sailors received two dozen lashes each and the valuable ornament was returned to its rightful owner. In 2018, a *tamau* collected on an early voyage to Tahiti was carefully studied and conserved at the British Museum and restored to something like its original appearance. Conservators estimate that when unrolled it would reach over 22 metres in length.

Dancing Girl
Tupaia, 1769
Pencil and watercolour on paper; 279 x 394 mm
The British Library

Ornament known as a tamau
Tahiti, 1700–1800
Human hair;
Length 22000 mm
The British Museum

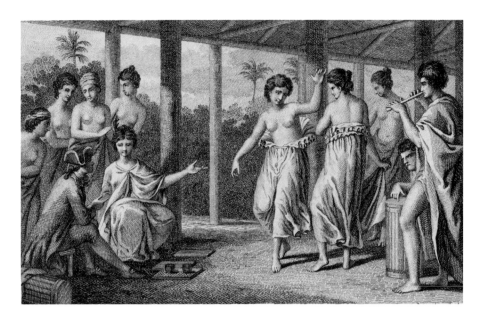

The print shown above, which is based on an account from a Cook voyage journal, stereotypes Tahiti as an island paradise with bare-breasted women dancing before a European officer. Another woman, who appears to be explaining the dance to the officer, may be a high-ranking Tahitian called Purea, who was very influential in early encounters with Europeans. Although the artist is no doubt appealing to a European audience with this imagined scene – the Islanders' barkcloth garments once again resemble Grecian robes – he has also made some attempts at accuracy by including Tahitian instruments such as a nose flute and a drum.

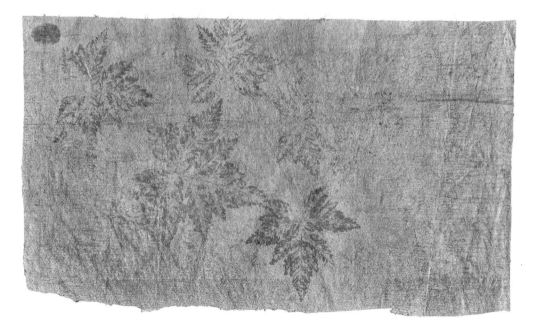

New wonder rose when ranged around for Thee, Attendant Virgins danc'd the TIMRODEE (top left)
Isaac Taylor, after Giovanni Battista Cipriani (1727–85), *c.* 1774
Etching and engraving on paper; 94 x 134 mm
The British Museum

Standing drum (top right)
Tahiti, 1700–1800
Wood, carved with a fish-skin tympanum; 625 x 162 mm
The British Museum

Piece of barkcloth decorated with leaf-print designs (bottom)
Tahiti, 1700–1800
Barkcloth; 280 x 200 mm
The British Museum

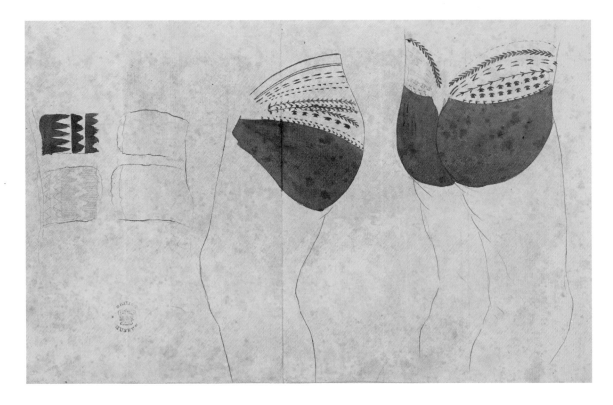

Tattooing mallet
Tahiti, 1700–1800
Wood; Length 393 mm
The British Museum

Tahitian tattoo designs
Sydney Parkinson, 1769
Pen and wash on paper;
380 x 300 mm
The British Library

Tattoo dye sample
Tahiti, 1860–69
Pigment; Height 100 mm
The British Museum

Tattooing instrument
Tahiti, 1700–1900
Wooden haft and handle, bone
blade and vegetable-fibre
lashing; Length 100 mm
The British Museum

European explorers were also intrigued and fascinated by the tattoos they witnessed on the bodies of Pacific Islanders. In Tahitian society, a person's status was inscribed on their skin. *Tatau*, the Tahitian term from which our word 'tattoo' comes, was recorded on Cook's first voyage. Although he described the practice as 'painting' the body, Cook understood that the way the ink was inserted beneath the skin made the patterns permanent.

Tattooing was carried out by specialists. The black dye came from the ash of burnt candlenuts and was applied beneath the skin using a sharp-toothed comb tapped by a small wooden mallet. For the recipient of the tattoo it was a long and painful process that required a good deal of courage to undergo. Many European sailors got tattoos of their own, while others collected tattooing instruments and brought them back to Britain, where they were the subject of great interest. Sydney Parkinson, an artist on Cook's first voyage, recorded some of the patterns he saw tattooed on the hips and buttocks of Tahitian men.

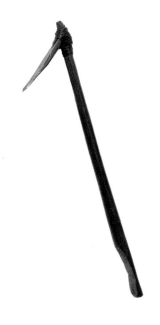

In Tahiti a person's status was made manifest not only by the tattoos on their skin but by the adornments that they wore on their body. Breastplates, known as *taumi*, were worn by men of high status, for example warriors. Made from prized materials such as feathers, dog hair and pearl shell, they were worn in pairs: one on the chest and one on the back. A row of sharks' teeth created the impression that the warrior's head was emerging from the jaws of the feared predator. During Cook's second voyage, his crew witnessed the assembling of a fleet of Tahitian war canoes, which greatly impressed them. William Hodges captured the scene in an image that includes a man wearing a *taumi* and a large headdress known as a *fau*.

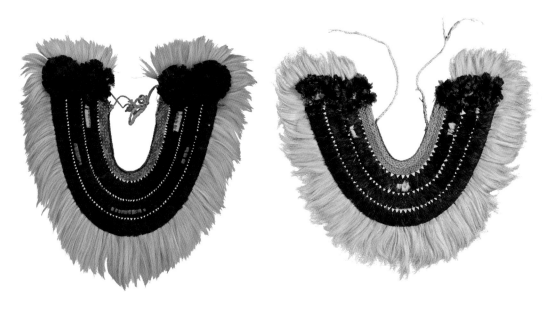

Taumi, **warrior's breast-plate**
Tahiti, 1700–1800
Feather, shark tooth, dog hair, fibre, coir, bark; 520 x 590 mm
The British Museum

Taumi, **warrior's breast-plate**
Tahiti, 1750–1800
Feather, cane, shark tooth, dog hair, fibre; 620 x 540 mm
The British Museum

The Fleet of Otaheite assembled at Oparee
William Woollett, after William Hodges, 1777
Etching on paper;
246 x 398 mm
The British Museum

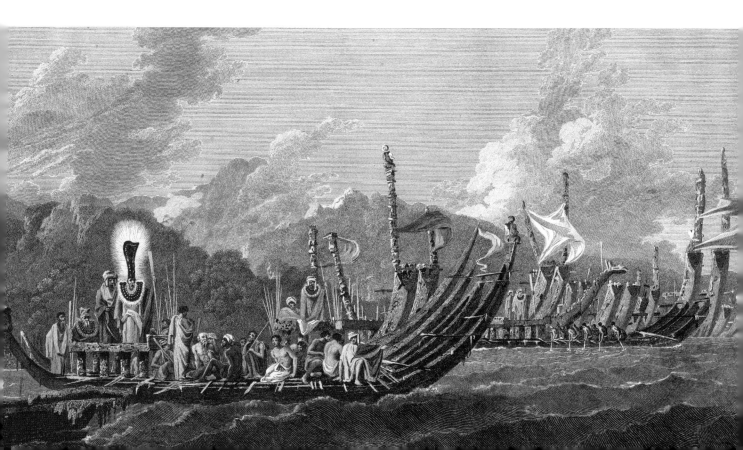

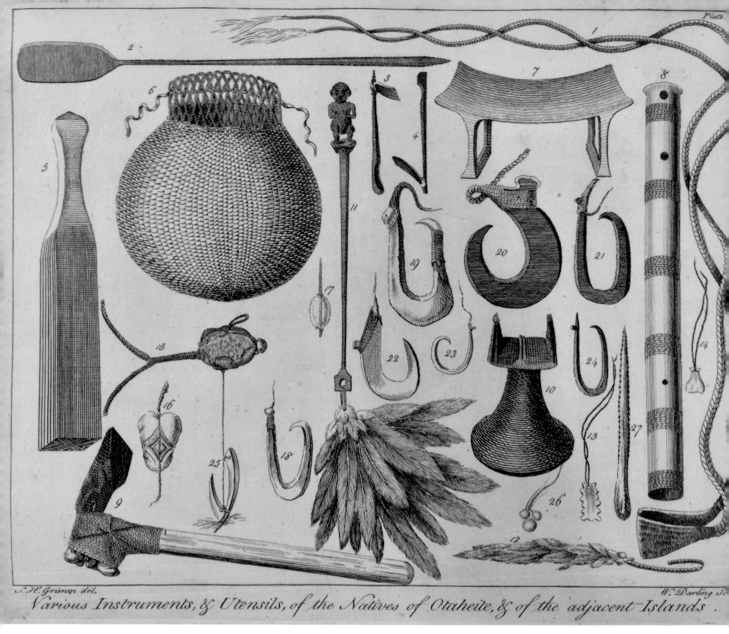

S.H. Grimm del. *W. Darling Sc.*

Various Instruments, & Utensils, of the Natives of Otaheite, & of the adjacent Islands

Although the voyages of Captain Cook were central to the development of the myth of Tahiti as an island paradise, Cook and his crew were also keen to document the more mundane realities of island life. They found the exotic even in the everyday and collected objects such as food pounders, beaters for making barkcloth, and adzes (a tool similar to an axe) used to build canoes and houses. Back in Europe, illustrations of these objects were included in the voyage journals that were published to great public interest and acclaim. Referred to as 'artificial curiosities', the objects were accurately depicted in terms of their construction and appearance, but their scale was altered so that the illustrations could be presented as though the objects were mounted in a display case. The idea was to give the viewer the illusion of seeing the whole of Tahitian culture at a glance.

Various Instruments, & Utensils, of the Natives of Otaheite, & the adjacent Islands
W. Darling, after S.H. Grimm and Sydney Parkinson (1745–71), 1773
Engraving on paper; 246 x 398 mm
The British Museum

Headrest
Tahiti, 1700–1800
Wood; 240 x 890 mm
The British Museum

Barkcloth beater
Tahiti, 1700–1800
Wood; 375 x 50 mm
The British Museum

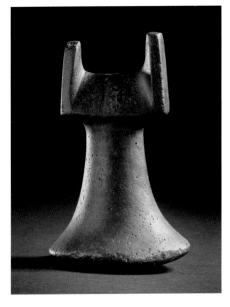

Food pounder
Tahiti, before 1878
Stone (basalt); 220 x 150 mm
The British Museum

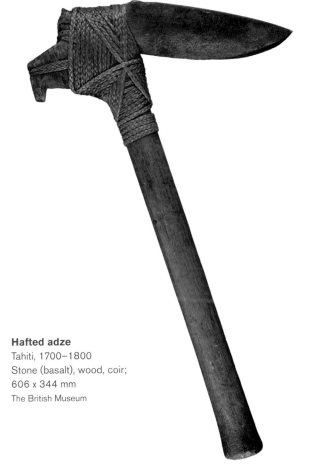

Hafted adze
Tahiti, 1700–1800
Stone (basalt), wood, coir;
606 x 344 mm
The British Museum

Nose flute
Tahiti, 1800–91
Bamboo; Length 434 mm
The British Museum

Collecting Gods

Tahitian god images, known as *to'o*, were receptacles into which the power of the gods could be channelled. Comprised of a wooden core encased in thick strands of plaited coconut fibre, many would have been originally decorated with feather attachments. European voyagers struggled to understand their divine nature; when botanist Joseph Banks (1743–1820) was taken to a temple, he snatched a sacred *to'o* and ripped off its coconut fibre bindings, causing deep distress to the priests present.

The *to'o* shown here is thought to have been collected on Cook's voyages. As Tahitians began to convert to Christianity, Islanders sometimes removed the coconut fibre bindings to take away the power of the *to'o*.

Staff, god image, *to'o*
Tahiti, 1700–1769
Wood and coir;
619 x 66 mm
The British Museum

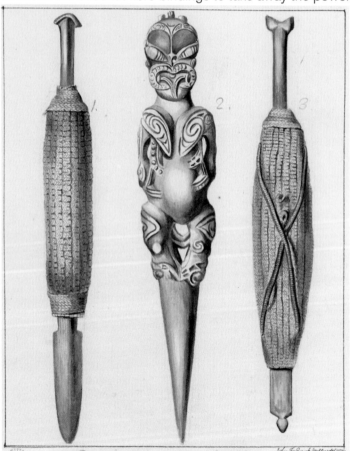

Two spades from Otaheite; in centre, a planting stick from New Zealand
Illustrative of Capt. Cook's first voyage, 1768 -1770, chiefly relating to Otaheite and New Zealand. From A. Buchan, John F. Miller, and others, *Drawings in Indian ink* (1769)

The Costume of the Chief Mourner

This complex costume, collected during Cook's second voyage, is known as a *heva tupapa'u*. It was worn by the Chief Mourner at ceremonies held by Tahitians to mark the death of an important person. Made from layers of rare and valuable materials, its swathes of barkcloth and mask fringed with red-tailed tropicbird feathers create an impressive bulk and height. A small slit in the pearl-shell mask was the only means of seeing, so the Chief Mourner was led around by a group of attendants. As he moved, he sounded pearl-shell clappers, the coconut-shell discs on the apron rattled and the shells on the breastplate shimmered. Together, these elements astounded and intimidated all who saw the costume.

Mourner's Costume, *heva tupapa'u*
Tahiti, before 1774
Bark, tropicbird feathers, pearl shell,
wood, coconut shell, turtle shell, hair, fibre, coir;
2110 x 815 mm
The British Museum

***A Toupapow, with a Corpse on it
attended by the Chief Mourner in his
Habit of Ceremony***
William Hodges, 1773
Etching on paper; 238 x 360 mm
The British Museum

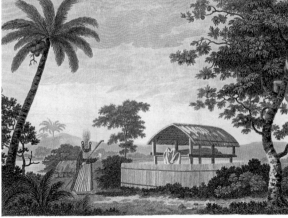

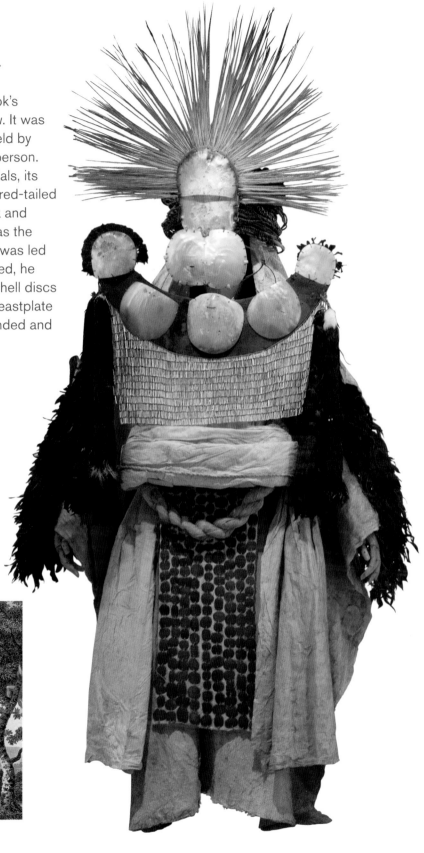

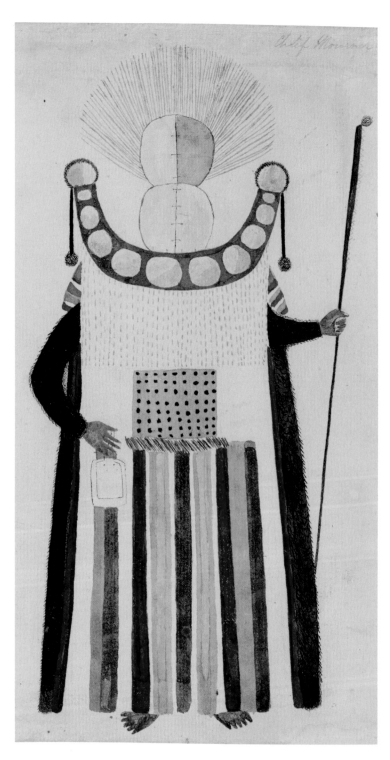

In June 1769, during Cook's first voyage, Joseph Banks observed a ceremony marking the death of an important Tahitian. Recording the spectacle in his journal he described how the Chief Mourner, dressed in just such a costume, emerged from the shadows of dawn or dusk. Keen to participate, Banks joined the troupe of attendants flanking the figure, stripping off his clothes and blackening his body with soot. He noted that people fled in terror 'like sheep before a wolf'. Cook was keen to acquire such a valuable and powerful costume, but the Islanders agreed to trade only when he returned on his second voyage carrying highly prized red parrot feathers from the islands of Tonga. A number of costumes were then traded, including one which came to the British Museum in the eighteenth century. Records show that it was on display by 1803.

What happened to the costume from the time that it was collected in Tahiti to when it was put on display at the Museum is unknown, but at some point in its history it was placed on an artist's easel. During conservation work undertaken in the 1960s, Museum staff found a Tahitian wooden ancestor figure, known as a *ti'i*, lashed to the top of the easel, but why or how it came to be placed there remains a mystery.

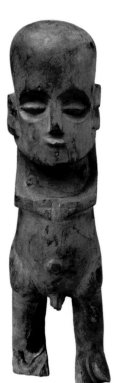

The costume of the Chief Mourner (left)
Tupaia, 1769
Pencil and watercolour on paper; 279 x 394 mm
The British Library

Ancestor figure, *ti'i* (right)
probably collected on Cook's second voyage
Tahiti, 1700–1774
Wood; 460 x 130 mm
The British Museum

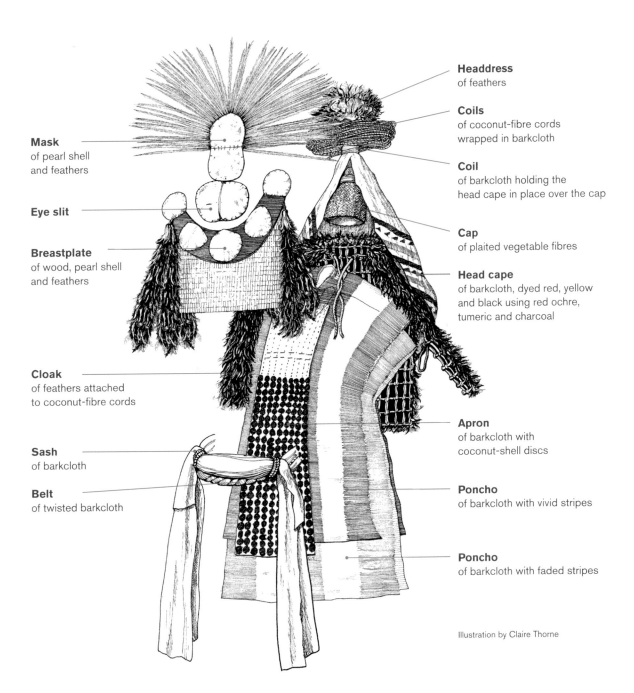

Mask
of pearl shell
and feathers

Eye slit

Breastplate
of wood, pearl shell
and feathers

Cloak
of feathers attached
to coconut-fibre cords

Sash
of barkcloth

Belt
of twisted barkcloth

Headdress
of feathers

Coils
of coconut-fibre cords
wrapped in barkcloth

Coil
of barkcloth holding the
head cape in place over the cap

Cap
of plaited vegetable fibres

Head cape
of barkcloth, dyed red, yellow
and black using red ochre,
tumeric and charcoal

Apron
of barkcloth with
coconut-shell discs

Poncho
of barkcloth with vivid stripes

Poncho
of barkcloth with faded stripes

Illustration by Claire Thorne

Today, the Chief Mourner's costume continues to astonish. In 2018 a team of conservators, scientists, mount-makers, artists and curators – including colleagues from Tahiti – dismantled the costume and removed the easel. Concealed within the folds of a bundle of barkcloth lashed to the easel was another surprise: a striped poncho or *tiputa*. Its vibrant red-orange stripes give an impression of just how dazzling the original costume must have been.

In the 250 years since Cook first set sail, objects known to have been collected on his voyages have have increased in desirability and value because of their 'Cook connection'. Treasures, like the Tahitian mourner's costume, have acquired a cult status among those who are fascinated by Cook.

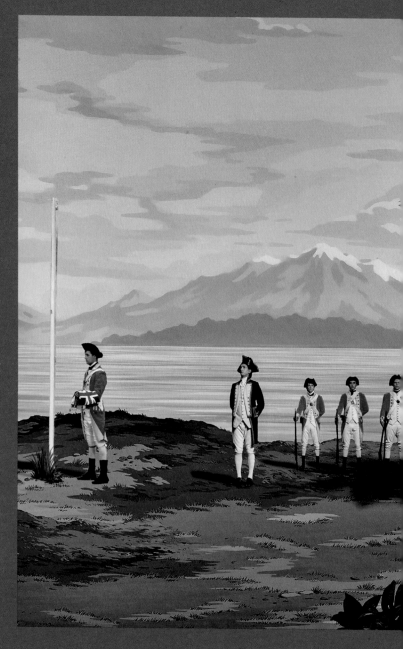

Lisa Reihana

This work is a still taken from Māori artist Lisa Reihana's celebrated panoramic video work *in Pursuit of Venus [infected]*. It brings to life scenes depicted on a nineteenth-century French wallpaper design, which show colourful, fantastical aspects of life in the Pacific Islands. Even though only a few small sections of the wallpaper survive, the intense colours and vibrant scenes still manage to convey its original impact, and their exotic, romanticized representation of Pacific peoples immediately captured Reihana's attention.

In a departure from the scenes shown on the original wallpaper, Reihana has inserted Europeans into the landscape. Here Captain Cook and his men are shown about to hoist the British flag on an unspecified Polynesian island, raising questions about what Europeans and Islanders might have understood by the idea of 'taking possession'. It is just one example of the way in which Reihana's twenty-first century reimagining of these early encounters has the power to spark fresh debate on their meaning.

Taking Possession, Lono
From *in Pursuit of Venus [infected]*
Lisa Reihana (born 1964)
Māori, Aotearoa New Zealand, 2017
Photographic print; 1560 x 760 mm
The British Museum

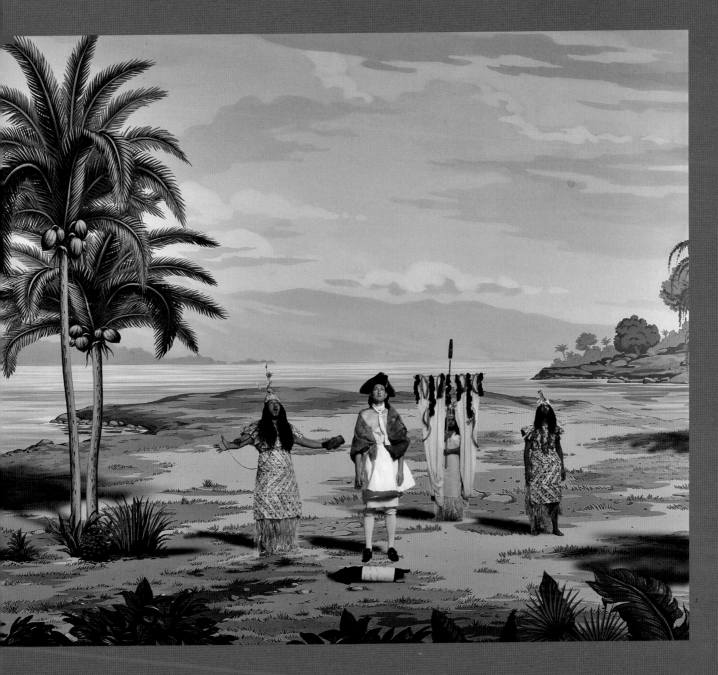

Once people have encountered each other,

history is changed forever… and that's the infection.

Lisa Reihana, 2016

Aotearoa New Zealand

One ship, two navigators

In 1769, as James Cook's time in Tahiti was drawing to an end, a new recruit joined the ship's crew. This was a Tahitian called Tupaia, a persuasive diplomat who had played a pivotal role in the interactions between Cook's men and the high-ranking Tahitian patrons he served. Tupaia had overseen the presentation of gifts, such as pigs, coconuts and bales of valuable white barkcloth to the expedition. He had also worked to smooth the waters when the intricacies of such presentations went awry and cultural misunderstandings threatened to offend. On one occasion, for example, Cook's men failed to recognize the significance of the barkcloth gifted to them and left it behind on the shore. Angry Islanders duly paddled out in a canoe to present the bales of cloth again.

A Tahitian War Canoe
Sydney Parkinson (1745-1771), 1769
Pen and wash on paper; 270 x 350 mm
The British Library

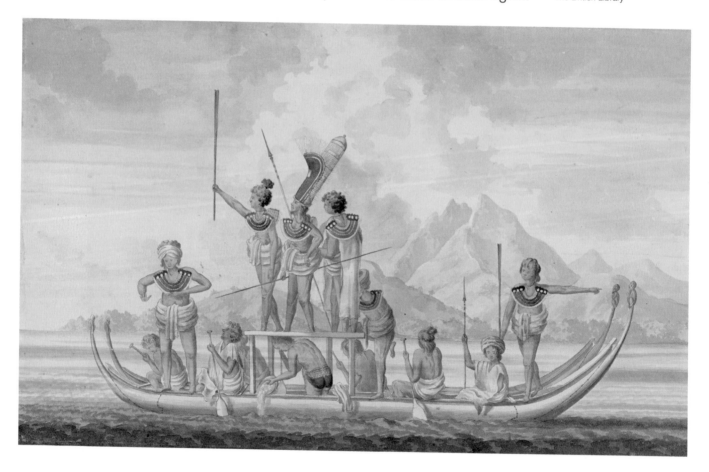

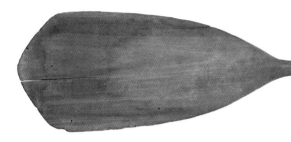

Canoe steering paddle (above)
Ra'iatea, 1700–1800
Wood; 1825 x 328 mm
The British Museum

Canoe ornament (below)
Tahiti, 1750–1850
Wood; 325 x 165 mm
The British Museum

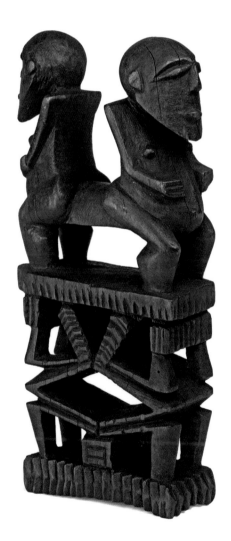

Tupaia came from a family of renowned and high-status priest-navigators. It was the role of such men to ensure that voyages passed safely and successfully not only by reading ocean currents, wave patterns and constellations, but by attaining the blessings of the gods. While no images exist of Tupaia himself, the men seen guiding a canoe in an image made by voyage artist Sydney Parkinson are probably priest-navigators. They are shown wearing fine barkcloth garments and feathered breastplates, while the figure in the centre of the image is wearing a large and imposing headdress known as a *fau*, thought to have been worn by men of high status in the context of battles. The priest-navigators carried out the priestly part of their role by using prayers and chants to channel the power of the gods. To receive and store this power, carved figures were often placed at the stern and prow of the canoes. The canoes themselves could be extremely large, some sporting double hulls and steered using paddles up to two metres in length.

With its new Tahitian crewman newly installed on board, *Endeavour* became a ship with two navigators. Tupaia duly shared his navigational knowledge with the crew and tried to persuade Cook to sail west into waters that the Tahitian knew well, but to no avail. In his journal, Cook noted with admiration that Tupaia was able to name over 100 islands but the explorer nonetheless decided to ignore the priest-navigator's entreaties and headed south in accordance with the Admiralty's instructions. Frustrated by this turn of events, Tupaia took up residence in a cabin that had belonged to one of the voyage artists who had died earlier in the journey. Inspired, Tupaia began to draw and created a series of now-famous illustrations. At some stage, a similarly famous chart depicting the islands around Tahiti was also drawn up using information gleaned from the ship's newest crew member. Today, the chart, which is known as 'Tupaia's map', is housed in the British Library and is a fusion of Polynesian and European cartography, the interpretation of which is still being debated.

When *Endeavour* arrived in Aotearoa New Zealand in October 1769, the similarities between Tahitian and Māori languages meant that Tupaia found a crucial new role as a mediator in the tense first meetings between Māori and Cook's crew. For Māori, the Tahitian represented a link back to their Polynesian ancestors; they wanted to know where he had come from, to talk with him and to look at the fine tattoos on his hips. Tupaia was therefore accorded respect for his great *mana* (status), with Māori chiefs gifting him their most treasured possessions such as dog-skin cloaks and greenstone ornaments.

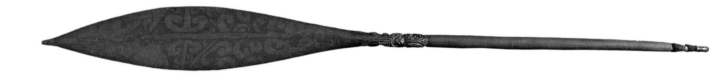

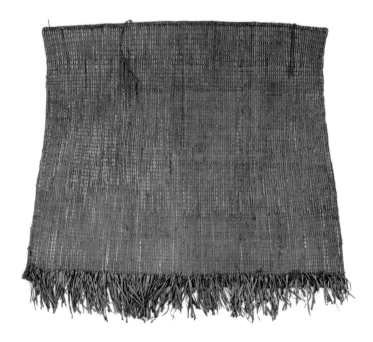

Cloak (left)
New Zealand, 1750–1800
Woven and sewn flax, dog
skin; 1085 x 1185 mm
The British Museum

Paddle (above)
New Zealand, 1750–1800
Carving on wood,
ochre, shark oil;
1790 x 50 mm
The British Museum

Even with Tupaia as a go-between, the first encounters between Māori and Cook's crew were fraught affairs in which mutual fascination and curiosity all too often gave way to confusion and violence. Māori were keen to acquire European metal tools, while Cook's crew were intrigued by the range of Māori weapons that could be made from wood, stone, whalebone or greenstone. Many of these encounters happened off-shore, with Māori paddling out to the ship to interact with Cook and his men. During one early exchange, Cook described how the Māori visitors eagerly traded everything they had brought with them, including the paddles from their canoes and 'hardly left themselves a sufficient number to paddle ashore'. Tupaia captured something of this dynamic in a drawing, which shows an officer, now understood to be *Endeavour*'s botanist Joseph Banks, trading Tahitian barkcloth with a Māori, who is offering a crayfish in return.

Once Cook left Aotearoa New Zealand and headed north for Australia, there was no longer a role for Tupaia on the voyage. It was a journey that he would not survive. When the *Endeavour* stopped over in Batavia (now Jakarta, Indonesia), almost all the crew became sick with malaria or dysentery and Tupaia was among several who died. It is testament to the important contribution that he had made that when Cook returned to Aotearoa New Zealand during his second voyage, Māori asked after Tupaia and wept when they learned of his death.

Cook's encounters in this region, including the places he visited, the objects he traded and the lives that were lost, are remembered by Māori people – and these memories continue to provide a significant perspective on the way that these events should be viewed. In 2019, on the 250th anniversary of Cook's arrival, his legacy in this part of the world continues to be contested.

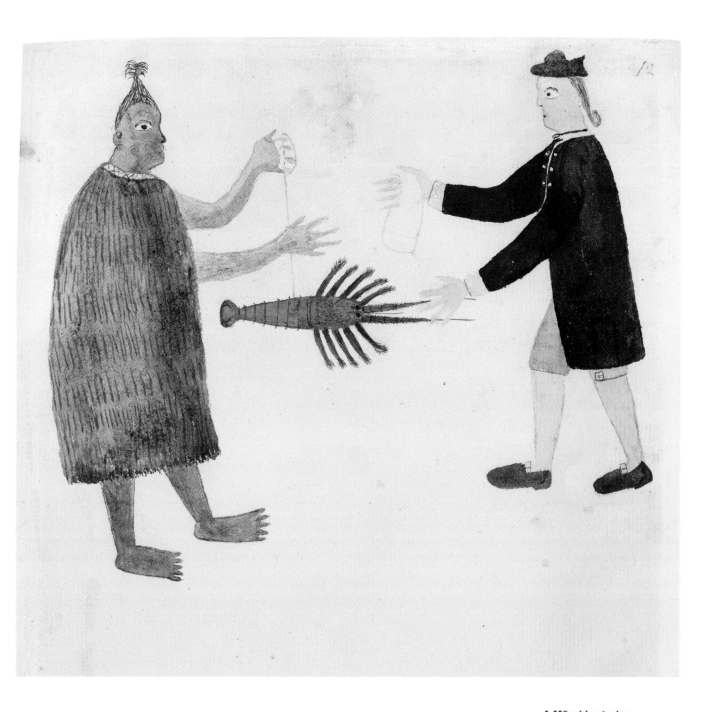

***A Māori bartering
with Joseph Banks***
Tupaia, 1769
Watercolour on paper;
268 x 205 mm
The British Library

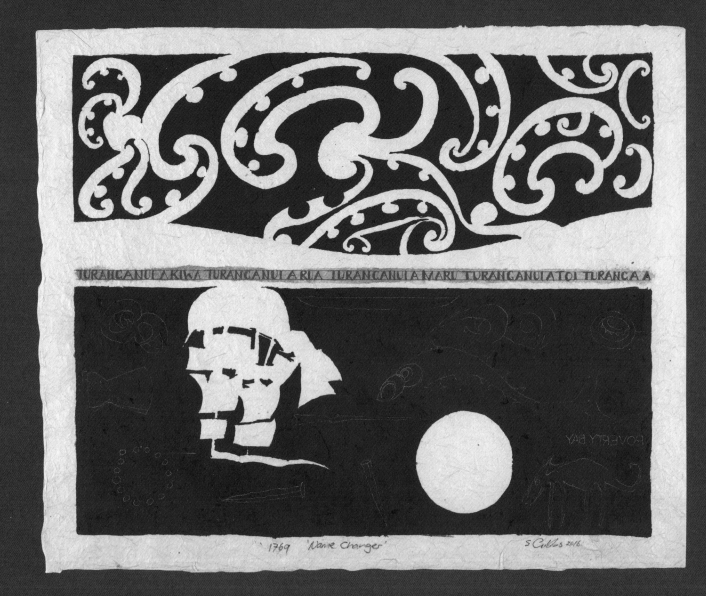

1769 'Name Changer' S Gibbs 2016

Steve Gibbs

Māori artist Steve Gibbs has spent years researching the *kowhaiwhai* patterns on Māori architecture and artefacts. Here they fill the space above *Endeavour*, which Gibbs depicts upside down. Across the centre are the names used by his ancestors for the region around Gisborne, which Cook renamed 'Poverty Bay'. Gibbs says: 'Everything we did was the complete opposite to their norm. The reality, however, is that Cook and his crew were the ones out of sync.'

Name Changer
Steve Gibbs (born 1955)
Ngai Tamanuhiri, Rongowhakaata, Rongomaiwahine
Aotearoa New Zealand, 2016
Acrylic on paper; 470 x 350 mm
The British Museum

John Pule

On his second voyage to the Pacific, Cook landed briefly on the island of Niue, which he named 'Savage Island'. In this print, which follows the traditional grid design of Niuean barkcloth, artist John Pule reflects on the exchanges and interconnections that resulted from the arrival of Europeans, for instance the introduction of Christianity and the availability of goods such as cloth and lamps.

Entanglements
John Pule (born 1962)
Niue, 1997
Lithograph; 530 x 630 mm
Collection of Annie E. Coombes
and Nicholas Thomas

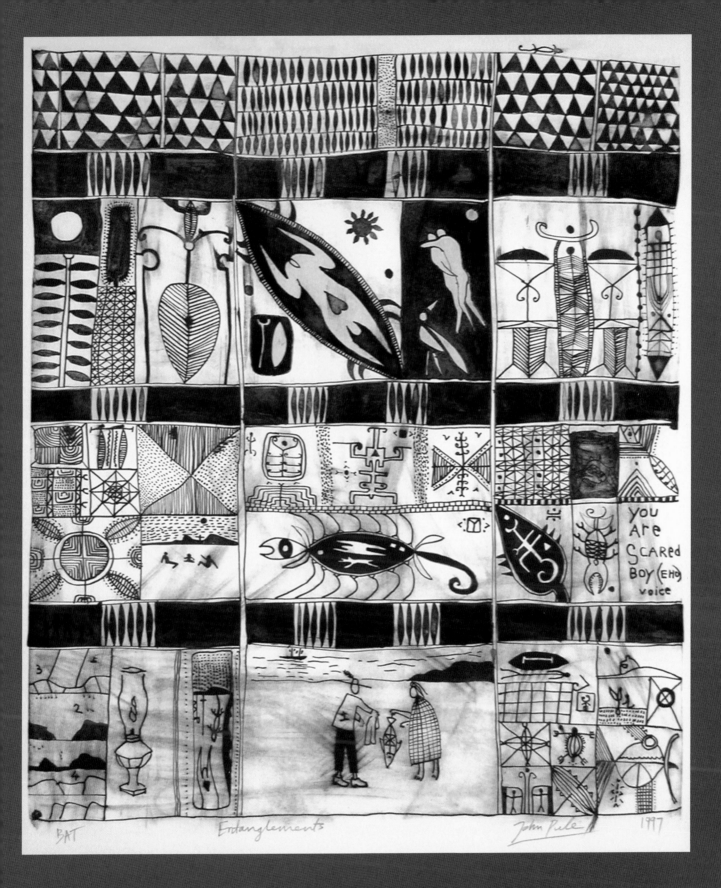

BAT Entanglements John Pule 1997

Australia

Misconceptions and Emblem of Empire

In 1770, while on his first voyage to the Pacific, James Cook landed on the east coast of Australia near present-day Sydney. After spending about a week anchored in 'Botany Bay' – so called because of the large number of plant specimens collected there by the botanist, Joseph Banks – Cook voyaged up the east coast. His ship then ran aground on the Great Barrier Reef and he took to shore to effect repairs to the damaged hull. Once he was ready to set sail again, he voyaged home through the Torres Strait, stopping at 'Possession Island' where he proclaimed the lands he had sighted for Britain.

Cook returned to Australia in January 1777, during his third voyage, spending some days in southern Tasmania where he met Aboriginal people. His explorations also had a much longer lasting impact: on 26 January 1788, a British penal colony was established at what is now Sydney – a date marked each year in Australia as 'Australia Day'. This colonization was only made possible as a result of information gathered on Cook's first visit.

Despite common misconceptions, Cook was not the first European to land on the continent of Australia; fellow Englishman William Dampier (1651–1715) had visited its northwest coast over eighty years earlier. Both men failed to understand the people or culture that they briefly encountered, and Cook in particular has become an increasingly divisive figure in Australia today. Aboriginal people from the Sydney region opposed his first landing in 1770 and Australia Day has long been the focus of protest and dispute. In 1938, for example, on the 150th anniversary of British colonization, Aborigines arranged a 'Day of Mourning' in Sydney and today many Indigenous Australians have taken to calling the anniversary 'Invasion Day' or 'Survival Day'. Indeed many Australians have demanded to change the date so that the nation can celebrate on a less contentious day of the year. As it is, until Indigenous disadvantage is redressed, it is likely that protests such as defacing statues of Cook will continue.

The artefacts illustrated in the following pages were collected later, but are of a type seen by Cook and his men.

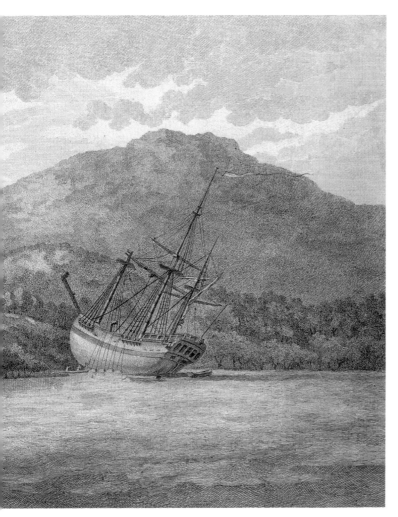

Cook's ship at Endeavour River, northeast Australia, 1770
William Byrne (1743–1805),
c. 1773
Engraving; 242 x 520 mm
The British Museum

Cook anchored at Endeavour River for seven weeks in 1770 to repair his ship. Although the Guugu Yimithirr people who lived there had already given this place a name, Waalumbaal Birri, Cook renamed it Endeavour River. Today the town beside the river is named Cooktown.

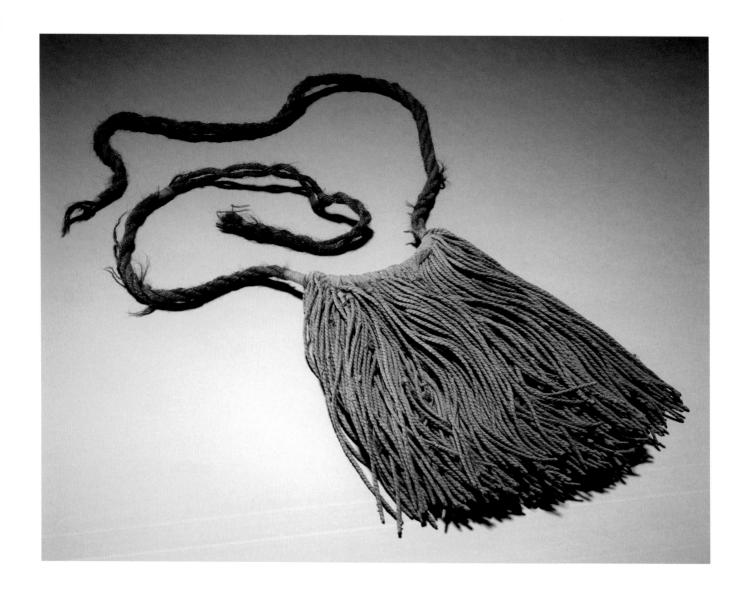

Aboriginal clothes, such as this skirt of fibre and hair, were so different to anything Cook had seen before that he did not recognize them as items of dress. Echoing earlier observations made by William Dampier, Cook noted in August 1770: 'We saw several naked people, all or most of them women, down upon the beach … they had not a single rag of Claothing upon them.'

Woman's skirt
Northwest Australia,
1800–1900
Fibre and hair string;
260 x 230 mm
The British Museum

Necklace (left)
Northeast Australia,
1800–1900
Shell; Length 820 mm
The British Museum

Breast pendant (middle)
Moa, Torres Strait,
1800–50
Pearl shell; 155 x 182 mm
The British Museum

Spear-thrower (right)
Northeast Australia,
1800–70
Wood, gum, shell and seeds;
850 x 80 mm
The British Museum

Cook was puzzled by the different systems of value held by Indigenous Australians and could not understand why Aboriginal people he encountered were not willing to trade some items, including those made of shell. He remarked in July 1770 in north Queensland: '[They] wore necklaces made of shells which they seem'd to Value as they would not part with them.'

On seeing bright shell ornaments in the Torres Strait, Cook remarked, 'Two or three of the Men we saw Yesterday had on pretty large breast plates…made of Pearl Oyster Shells…as well as the Bow and Arrows we had not seen before.'

Cook's crew originally mistook the purpose of Aboriginal spear-throwers. Joseph Banks commented in 1770: 'With this contrivance, simple as it is, and ill-fitted for that purpose, they throw the lances 40 yards or more… these I believe to be the things which many of our people were deceived by, imagining them to be wooden swords.'

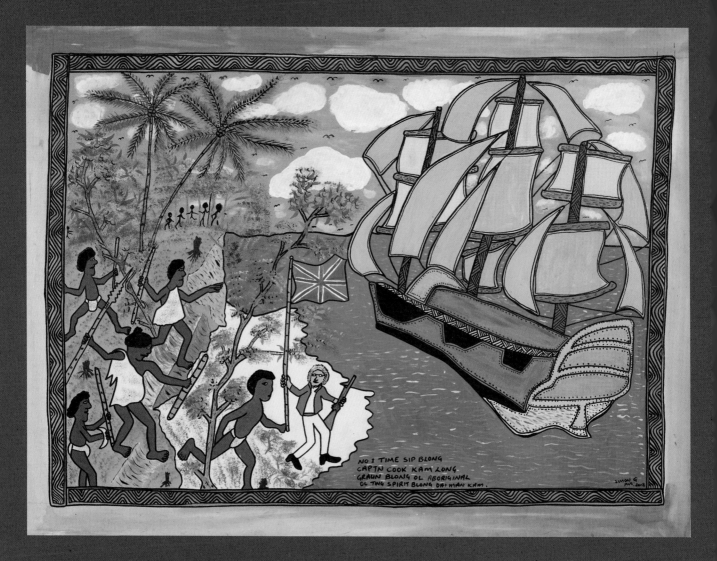

Within the image: NO 1 TIME SIP BLONG CAPTN COOK KAM LONG GRAUN BLONG OL ABORIGINAL OL TNG SPIRIT BLONG DAI MAN KAM.

Simon Gende

Artist Simon Gende lives in the highlands of Papua New Guinea and likes to paint world events. Influenced by the famous Papua New Guinea artist, Mathias Kauage, Gende says: 'Most of my paintings are about big news stories in the world because most of people like to buy them because they want to keep the stories of what they heard over the news. It's something like keeping history on the painting.' This work depicts Cook arriving in Australia and the hostile reception he received. The Aboriginal men on shore are defending their lands with shields and spears, while the European man, Cook, carries the British flag and a gun. Gende's depiction pinpoints the moment of that historic encounter and the subsequent loss of Aboriginal autonomy to British law – a pivotal event that continues to spark debate.

Captn Cook in Australia
Simon Gende (born 1969),
Papua New Guinea, 2018
Acrylic on canvas; 820 x 1090 mm
The British Museum

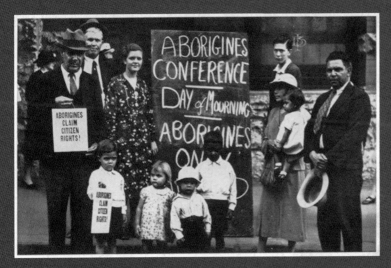

The national day of Australia is currently 26 January – the date in 1788 that a British settlement was established in present-day Sydney. On the 150th anniversary of that date, Aboriginal people and supporters came together in Sydney and proclaimed a 'Day of Mourning' declaring:

WE, representing THE ABORIGINES OF AUSTRALIA, assembled in conference at the Australian Hall, Sydney, on the 26th day of January, 1938, this being the 150th Anniversary of the Whiteman's seizure of our country, HEREBY MAKE PROTEST against the callous treatment of our people by the whitemen during the past 150 years, AND WE APPEAL to the Australian nation of today to make new laws for the education and care of Aborigines, we ask for a new policy which will raise our people TO FULL CITIZEN STATUS and EQUALITY WITHIN THE COMMUNITY.

Day of Mourning (above)
Left to right: William (Bill) Ferguson, Jack Kinchela, Isaac Ingram, Doris Williams, Esther Ingram, Arthur Williams Jr, Phillip Ingram, unknown, Louisa Agnes Ingram holding daughter Olive, Jack Patten.
Sydney, 26 January 1938
Photograph; 120 x 170 mm
The State Library of New South Wales

Micky Allan

This is one of a series of artworks from *The Bicentennial Folio* – commissioned by the Australian Bicentennial Authority and the National Gallery of Australia to mark the 200th anniversary of British settlement in 1788. As in 1938, the anniversary inspired a number of protests, but this time the participants also included many non-Indigenous Australians. In this work, artist Micky Allan focuses on the spot at Botany Bay near Sydney where Cook first came ashore on 29 April 1770. The upper image depicts a small silver statue of Captain Cook, while the lower one shows a quote from a plaque on the Cook monument at Botany Bay. The quote is taken from Cook's journal: 'The natives resolutely disputed the landing… although they were but two, and we thirty or forty at least.' When Allan returned to the spot in 2010, she found that the plaque had been removed.

Untitled: Captain Cook (right)
From *The Bicentennial Folio*
Micky Allan (born 1944), 1987
Screenprint on paper; 754 x 560 mm
The British Museum

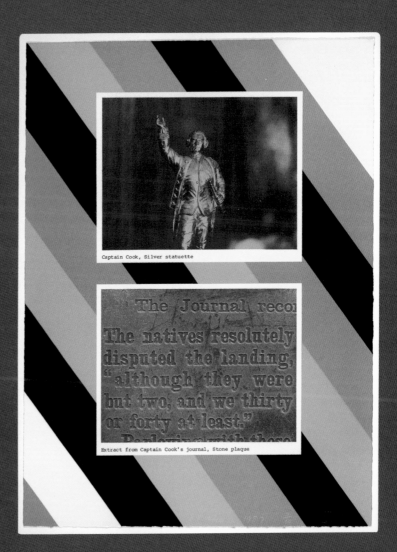

Captain Cook, Silver statuette

Extract from Captain Cook's journal, Stone plaque

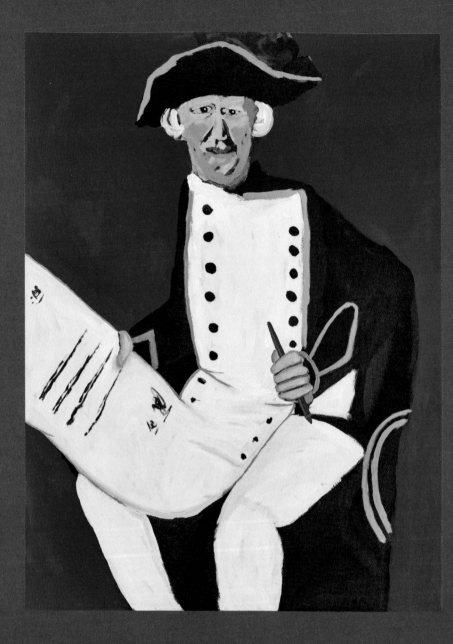

*James Cook -
with the Declaration*
Vincent Namatjira (born 1983)
Western Arrernte people, 2014
Acrylic on canvas;
1010 x 760 mm
The British Museum

Vincent Namatjira

Aboriginal people across Australia have long told stories about Captain Cook, all of which throw a spotlight more generally on relationships between Indigenous and settler Australians. Artist Vincent Namatjira was born in Hermannsburg in the Northern Territory of Australia and is himself a descendant of the famous Arrernte watercolour artist Albert Namatjira, who also came from from the same community. During a school excursion when he was fourteen, Vincent visited a replica of Cook's ship *Endeavour* at Fremantle, Western Australia, which, in his words, 'got me thinking about him'. This painting portrays Cook's written claim of possession of the east coast of New Holland in 1770 as an extension of his naval uniform, drawing links between Britain's military power, its possession of Aboriginal land and the imposition of British law. The artist says: 'This painting is important for me, because it was the beginning of our shared history, everything after Cook was between all of us.'

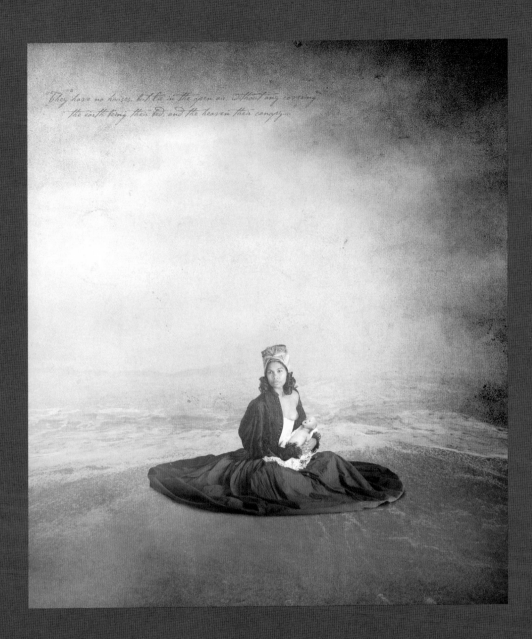

Civilised #12
Michael Cook (born 1968),
Bidjara people, Australia, 2012
Inkjet print on canvas;
1600 x 1400 mm
The British Museum

Michael Cook

This image is from Michael Cook's 2012 series *Civilised*, in which Cook photographs Aboriginal people dressed in European style. Here, a woman, finely dressed in European terms, holds a doll. In the top left corner of the image are words written by William Dampier, the first English person to visit Australia, in 1688: 'They have no houses, but lie in the open air, without any covering; the earth being their bed, and the heaven their canopy.'

Dampier's words reflect the low place accorded Aboriginal Australians in the eyes of the British from first contact. Seeing people who dressed so differently and lived their lives in a land without fences or brick houses, he described them as 'the miserablest in the world'. In contrast, when reflecting on his own visit, James Cook wrote that Aboriginal Australians 'may appear to some to be the most wretched people upon earth; but in reality they are far happier than we Europeans'. Highlighting the cultural biases inherent in the term 'civilised', Michael Cook says his work asks questions and seeks 'to show people that there are colours between black and white'. He concludes: 'A lot of people don't really understand the position of Indigenous people, even today.'

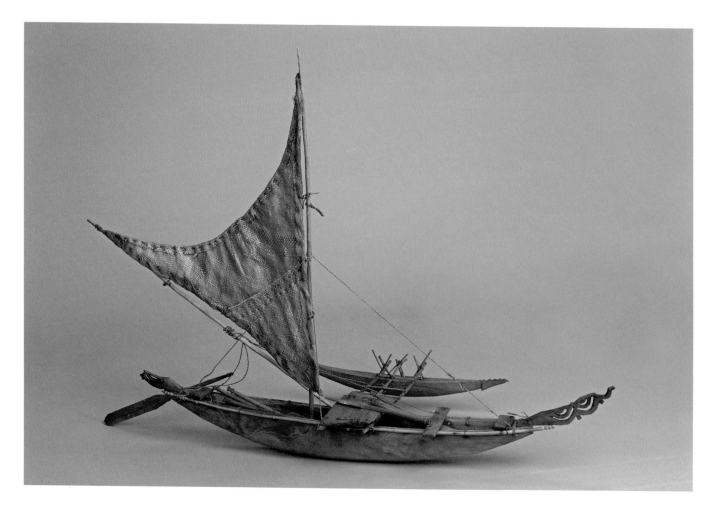

Vanuatu

Not the only ship

It was in 1774, during his second voyage, that Cook arrived in Vanuatu. The archipelago was already a hub for trade routes within and beyond its many islands, and large double-hulled sailing canoes had been a common sight on its waters for over 3,000 years. Cook's ship, the HMS *Resolution*, may have looked very different but to the Islanders it was another sailing vessel – and not the first European one that they had encountered. Cook the first European explorer to visit the region: Spaniard Fernandez De Quiros and French explorer Louis-Antoine de Bougainville had ventured here before in 1606 and 1768 respectively.

On arrival in Vanuatu, Cook named the first place he anchored 'Port Sandwich'. Discouraged by the Islanders from getting supplies of wood, food or water, he stayed there for only two days but recorded that there were many people in the area, a few of whom came on board.

Model outrigger canoe (left)
Northern Malakula,
1800–81
Wood with triangular plaited
grass sail, wooden bailer,
seven wood paddles and
wood steering paddle;
Length 787 mm
The British Museum

Canoes in Vanuatu were designed to sail the waters of the archipelago. This model accurately depicts a local trading canoe. Its triangular sails, plaited from the leaves of the pandanus plant, were highly effective in capturing and channeling the wind, while the boom to the side – known as an outrigger – helped balance the canoe against being blown over. As there was only one outrigger, this type of canoe had prows at both ends to harness the wind and propel the vessel in any direction.

Locally traded textile (right)
Ambae, Vanuatu, 1900–50
Pandanus leaf and vegetable dye;
1410 x 530 mm
The British Museum

For over 200 years, women on the Vanuatu island of Ambae have made special textiles, known as *singo*, by processing and plaiting pandanus leaves and dyeing them using a unique stencilling technique. Men from the island of Malakula sailed in trading canoes to acquire such textiles from Ambae.

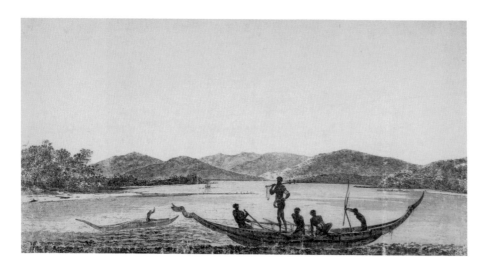

A view of Port Sandwich [at Malakula, Vanuatu] (left)
William Hodges, 1774
Ink, wash and watercolour on paper; 622 x 1195 mm
The British Library

Armband (below, middle)
Possibly Malakula, 1900-1913
White shells and black coconut wood beads; Length 173 mm
The British Museum

Club (below, right)
Ambrym, 1800–1900
Polished wood; 1125 x 105 mm
The British Museum

Man of the Island of Mallicolo (below, left)
William Hodges, 1774
Etching and engraving on paper; 228 x 182 mm
The British Museum

Understanding what you see

In the drawing above of Port Sandwich, by William Hodges, a man in one of the canoes is carrying a club over his shoulder. Such distinctive clubs, as seen below, were acquired through inter-island trade with the nearby island of Ambrym, where they were made. The man is also wearing a shell armband similar to that illustrated below, possibly from northern Malakula. The man's clothes and club, which demonstrate his access to goods from other places, emphasize his high status.

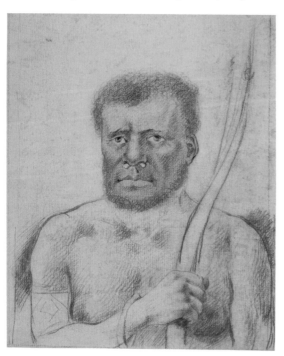

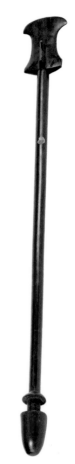

When some Islanders came on board the *Resolution* at Port Sandwich, Hodges took the opportunity as voyage artist to draw their portraits. This man is wearing a shell armband on his upper arm, indicating his high social rank.

James Zepeta

Among the objects Vanuatu's first settlers brought with them in their canoes were large thin-walled earthenware pots, with complex repeating designs stamped into them with comb-like tools. James Zepeta is a contemporary Ni-Vanuatu carver who makes bowls – such as this one carved from *kohu* wood – that reimagine these pots, which are today found only in fragments on archaeological sites.

Pot
James Zepeta (born 1962),
Tongoa Vanuatu, 2016
Wood; Diam. 240 x 355 mm
The British Museum

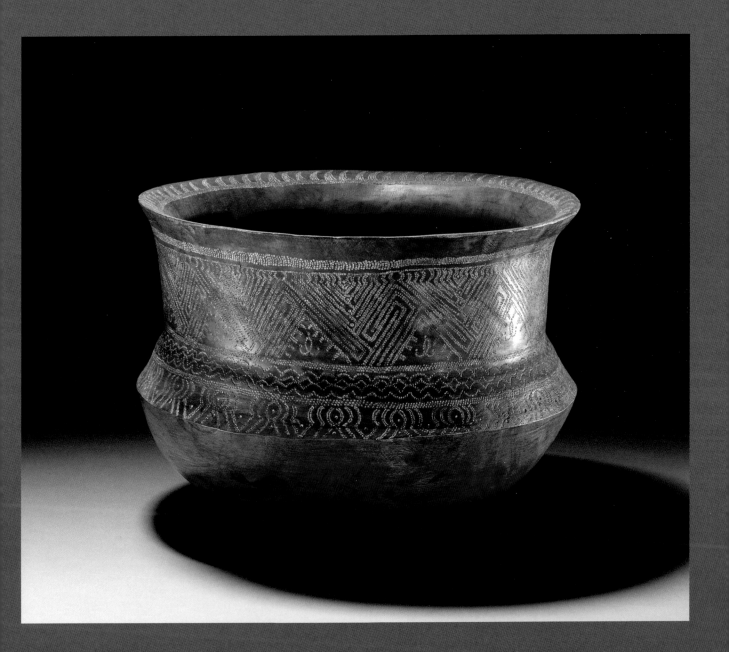

New Caledonia
Depending on the day

When Cook landed at Balade, New Caledonia, in September 1774, he and others on the *Resolution* were favourably impressed by the people they met. He wrote that 'no people could behave with more civility than they did'. Nine years later, the French explorer D'Entrecasteaux (1737-1793) also visited Balade, describing the people as surly and treacherous. His experience may have been the result of recent warfare, as he saw a large number of men with fresh wounds.

It is clear that Cook's visits were but a momentary interval in a long history for the communities he visited. The reaction of Islanders to him was dependent on what was happening at the time in their societies. Such different experiences are sometimes reflected in the objects collected on different expeditions.

In his voyage journals, Cook described the men in Balade as wearing 'cylindrical stiff black caps', illustrated in this print, *Man of New Caledonia,* after William Hodges, the voyage artist. Here, the cap is undecorated except for a rope spear-thrower tucked into the band, much like the one below.

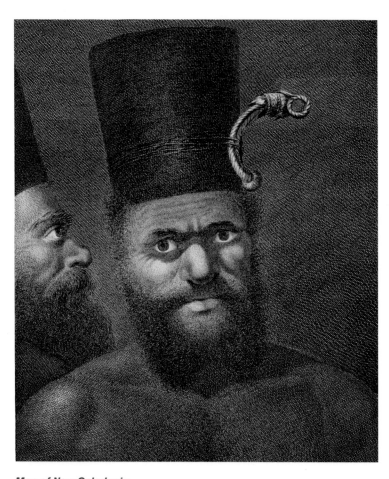

Man of New Caledonia
After William Hodges, 1777
Engraving on paper;
300 x 240 mm
The British Museum

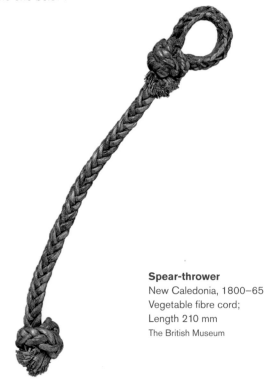

Spear-thrower
New Caledonia, 1800–65
Vegetable fibre cord;
Length 210 mm
The British Museum

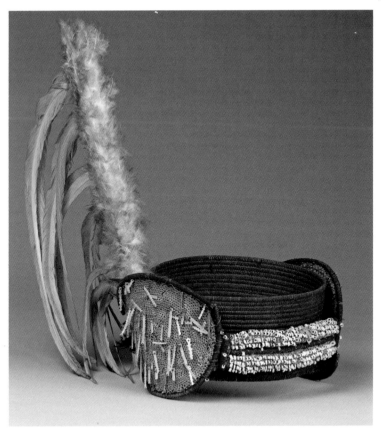

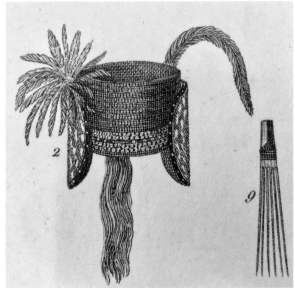

D'Entrecasteaux also saw black caps. An account of his voyage (made between 1791 and 1794) written by Julien Laferrière, a French captain, refers to a cap similar to the one illustrated above. Worn by chiefs, the examples recorded were highly decorated with valuable materials, such as 'flying fox fur rope and white cock feathers' and a pearl-shell embellished ornament.

Headdress band (top left)
New Caledonia, 1860–69
Fibre, shell discs, pearl shell,
white feathers;
370 x 210 mm
The British Museum

Elaborate black cap
(top right)
from New Caledonia;
detail of plate XXXVII.
After Julien Laferrière
From M. Labillardière,
*Voyage in search of La
Pérouse, 1791-1794*,
Vol. II, 1800

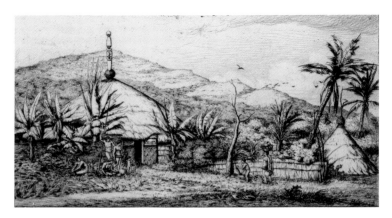

*Nouvelle Calédonie:
grande case indigène sur le
chemin de Ballade à Poépo*
Charles Meryon (1821–68),
1860
Etching on paper;
142 x 245 mm
The British Museum

Aloi Pilioko

In some Pacific Islands, stories of Cook's visits – and the events that occurred during them – have not been passed down through the generations, so the depictions crafted by contemporary artists tend to focus on an imagined moment of arrival. Artist Aloi Pilioko started making embroidered works on hessian sacks in the early 1960s. In this work he depicts his perspective on Cook's arrival in New Caledonia. The location is unmistakable thanks to the style of the chief's house in the top left corner, which is similar to those seen by Cook.

Cook
Aloi Pilioko (born 1935)
Wallis Island, New Caledonia,
1981
Crewel work, hessian and
wool;
1100 x 840 mm
The British Museum

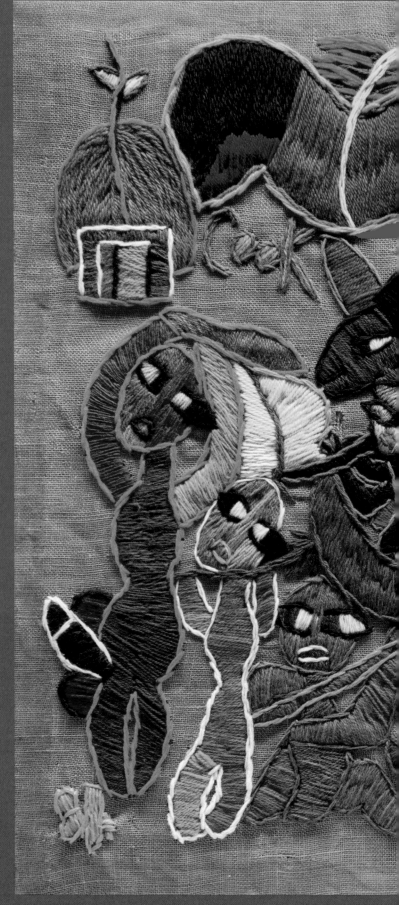

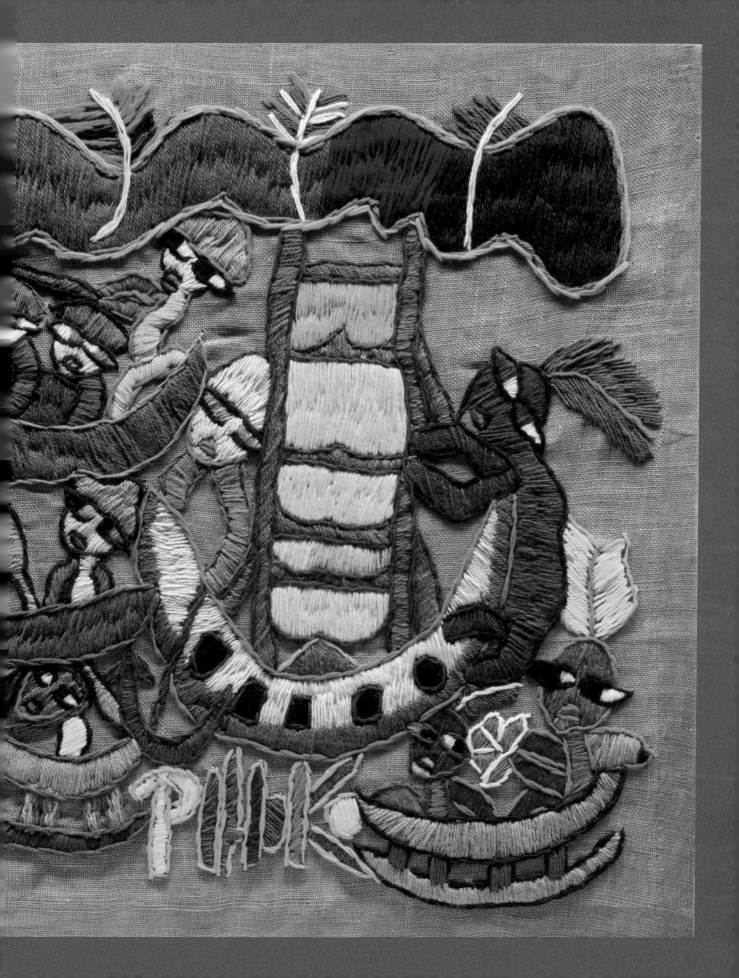

Hawaii

Mistaken identity

Sailing together on James Cook's third voyage, the *Resolution* and the HMS *Discovery* arrived in the Hawaiian archipelago in early 1778. To his surprise, Cook found that the culture he encountered was similar to that of Tahiti and wondered, 'How shall we account for this Nation spreading itself so far over this Vast ocean?' Unable to secure a good anchorage, the ships sailed on to the northwest coast of America, returning at the end of the year to the island of Hawaii itself. This second visit happened to coincide with a religious festival at which the Hawaiians seem to have celebrated Cook as the temporary embodiment of their god, Lono.

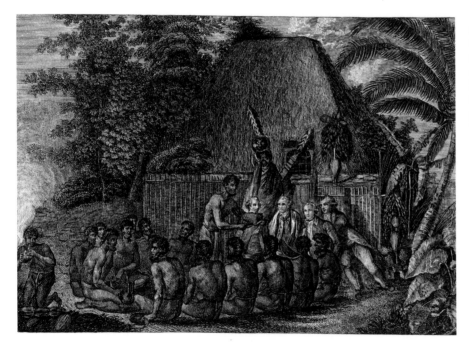

An Offering before Captn. Cook in the Sandwich Islands
After John Webber, artist on the third voyage, 1750–1800
Etching and engraving on paper; 140 x 182 mm
The British Museum

Cook's ships left the island of Hawaii in February 1779, intending to explore the rest of the archipelago. However, a few days later the mast of the *Resolution* was damaged in a storm, so they returned to the island for a third time. Only a short interval had elapsed but the reception awaiting them was quite different. Perhaps because the season associated with the god Lono had passed, the crew were no longer made welcome. The atmosphere became tense and a dispute caused by thefts from Cook's ships escalated into a confusion of fighting at the water's edge. By the time it was over, Cook had been killed. He was fifty years old.

From that day, Cook's death has been the subject of conflicting explanations and interpretations. In Hawaii, attitudes towards Cook have been complicated by the subsequent history of the archipelago. American missionaries, for example, helped to fuel general anti-English sentiment, which has led to Cook's reputation becoming marred by association.

Cloak
Hawaii, 1700–50
Olona fibre, red *'i'wi*, yellow
'o'o and black cock's feathers;
1750 x 2230 mm
The British Museum

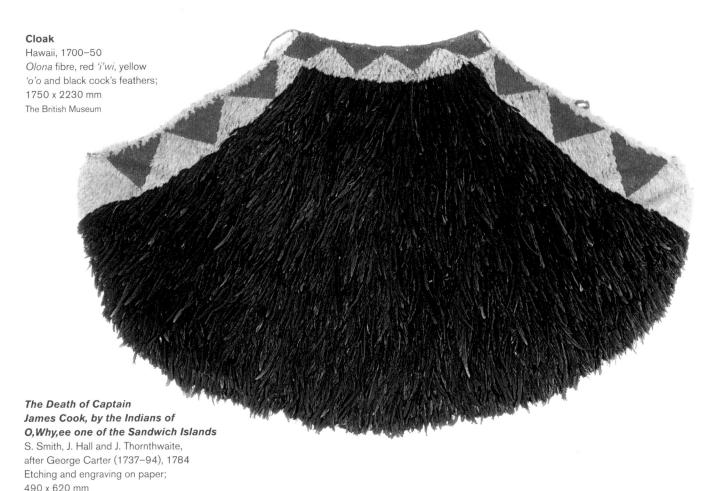

***The Death of Captain
James Cook, by the Indians of
O,Why,ee one of the Sandwich Islands***
S. Smith, J. Hall and J. Thornthwaite,
after George Carter (1737–94), 1784
Etching and engraving on paper;
490 x 620 mm
The British Museum

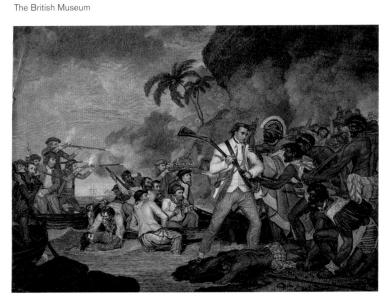

During his first visit to Hawaii, Cook tried to acquire a feather cloak but was not able to do so. He was pleasantly surprised then – amid the warmth of the reception he received on his second visit – to be presented with six. His second lieutenant James King (1750–84) commented that on this second visit, which coincided with a religious festival, the Hawaiians 'seemed to promise us every assistance they could afford us'.

This cloak is made from *olona* fibre, red *'i'wi*, yellow *'o'o* and black cock's feathers. It is believed to have been given to Captain Clerke (1741–79), Cook's second-in-command, by Kaneoneo, chief of the island of Kaua'i. A man wearing a similar cloak is depicted in the image of Cook's death.

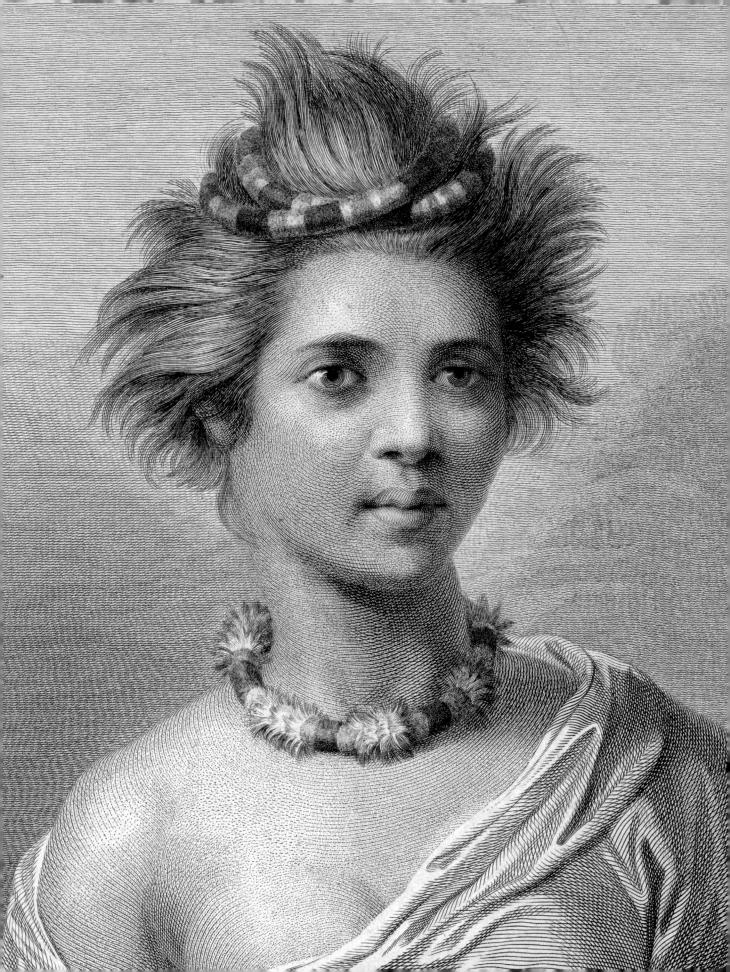

Head or neck ornaments, *lei*
Hawaii, 1700–95
Feathers and vegetable fibre
cord; Average length 407 mm
The British Museum

This gentle portrait of a young woman,
Poeta, reflects the harmonious period
of Cook's second visit to Hawaii. She
is wearing a headband and a feather
necklace, similar to the ones shown here.
A dreadful legacy of the visits of Cook
and his crew was a devastating spread
of venereal disease throughout Hawaii,
despite Cook's orders that no crew
members with the disease were to
leave the ships.

Poeta, a woman of the
Sandwich Islands
J.K. Sherwin, after John Webber,
artist on the third voyage, 1785
Etching and engraving on paper;
357 x 294 mm
The British Museum

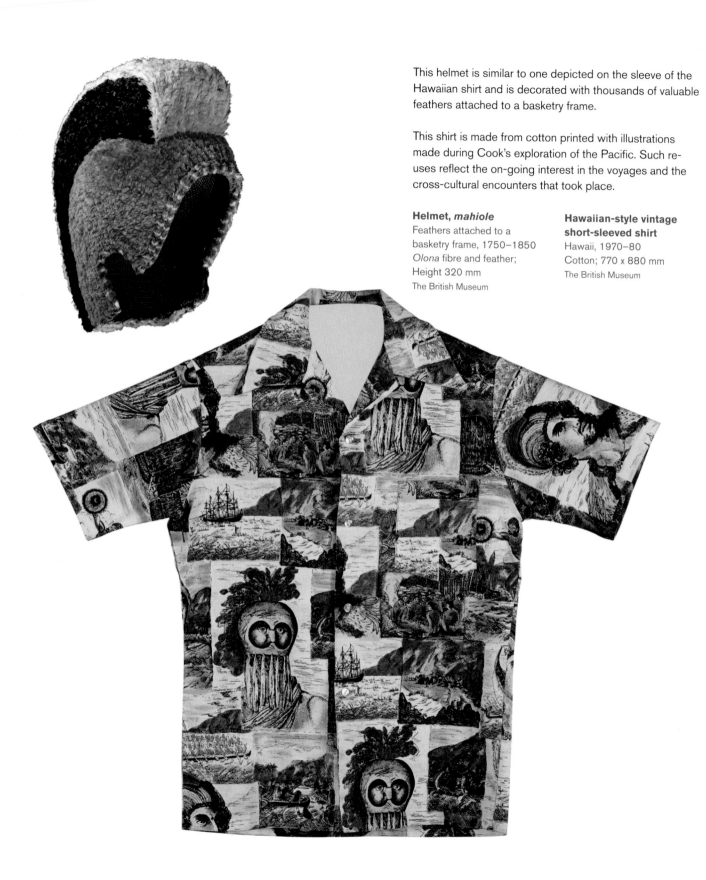

This helmet is similar to one depicted on the sleeve of the Hawaiian shirt and is decorated with thousands of valuable feathers attached to a basketry frame.

This shirt is made from cotton printed with illustrations made during Cook's exploration of the Pacific. Such re-uses reflect the on-going interest in the voyages and the cross-cultural encounters that took place.

Helmet, *mahiole*
Feathers attached to a
basketry frame, 1750–1850
Olona fibre and feather;
Height 320 mm
The British Museum

**Hawaiian-style vintage
short-sleeved shirt**
Hawaii, 1970–80
Cotton; 770 x 880 mm
The British Museum

Marques Hanalei Marzan

Towards the end of the twentieth century, Indigenous Hawaiians intensified their interest in their cultural history and in making traditional objects using traditional techniques and materials. Marques Marzan's work, which bridges the traditions of the past and the innovations of the present, has led him to study fans collected by Europeans on early voyages and now held in museums around the world. Woven from pandanus leaves, this example was commissioned from Marzan by the British Museum and is inspired by its collection of Hawaiian fans.

Fan
Marques Hanalei Marzan
(born 1979)
O'ahu, Hawaii, 2018
Pandanus leaves, coir;
390 x 318 mm
The British Museum

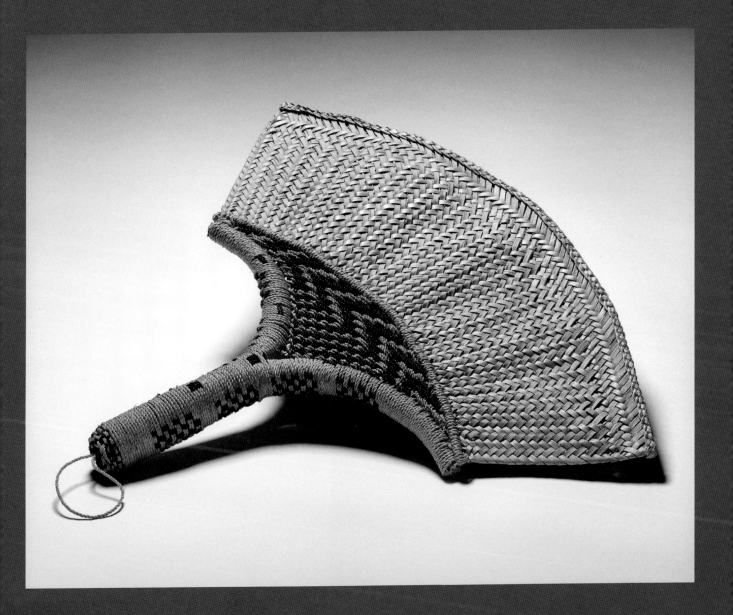

Britain

A useful hero

During his lifetime Cook's impressive navigational skills were recognized by the Admiralty, the Royal Society and the European readers of his voyage accounts. His death in 1779 came in the middle of the American Revolutionary War, and the official publication of his third voyage account came in 1784 – a year after the war had ended with defeat for the British. Set against this background, and with Britain turning its imperial ambitions away from the Americas and towards growing success in Asia and the Pacific, Cook was shaped into a national hero for Britain and its growing Empire. His popularity was widespread and his achievements were promoted through prints, publications, objects, artworks, pantomimes, museum displays and memorials.

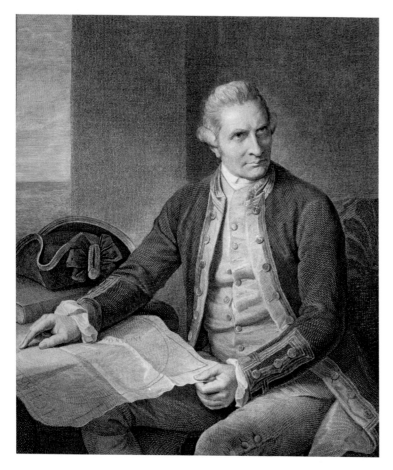

A small number of portraits of Cook were produced during his lifetime. The best known and most copied was produced by society artist Nathaniel Dance in 1776 and commissioned by the botanist Joseph Banks. Cook was represented as a captain and learned navigator, gesturing to the location of Australia (*Terra Australis*) on a map that he helped to complete. This image was widely reproduced in print.

Captain James Cook
J.K. Sherwin, after Nathaniel
Dance (1748–1827), 1784
Engraving; 502 x 329 mm
The British Museum

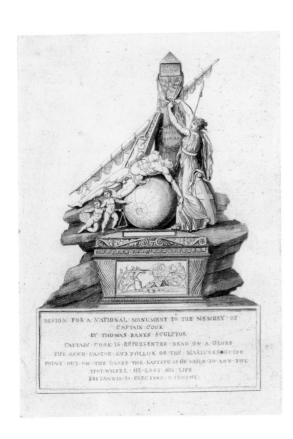

News of Cook's death reached Britain in January 1780 and, in the same year, a design for a national memorial to him was presented by the artist Thomas Banks at the Royal Academy of Arts exhibition. The figure of a martyr is depicted lying over a globe, while the female figure of Britannia attaches a sail to a monument behind. The design failed to excite a public response and was never built and, although some individuals did build private memorials to Cook in these early years, it would take longer for his distinctive public status to be forged.

Early depictions of Cook's death varied in Europe due to the inconsistent reports about how it had occurred. In the illustration for the official voyage publication, after the artist John Webber, Cook is shown standing at the edge of the shore at Kealakekua Bay in Hawaii. A figure behind him lifts a knife while Cook himself gestures to men in a nearby boat. This raised arm was interpreted by some as Cook attempting to stop his crew from firing on the Hawaiians, which perhaps explains why, after this image was published, he was increasingly depicted by Europeans as a benevolent figure.

Design for a national monument to the memory of Captain Cook (left)
Thomas Banks (1735–1805), 1781
Etching and aquatint on paper; 321 x 277 mm
The British Museum

The Death of Captain Cook (below)
Francesco Bartolozzi and William Byrne, after John Webber, 1784
Etching on paper; 480 x 605 mm
The British Museum

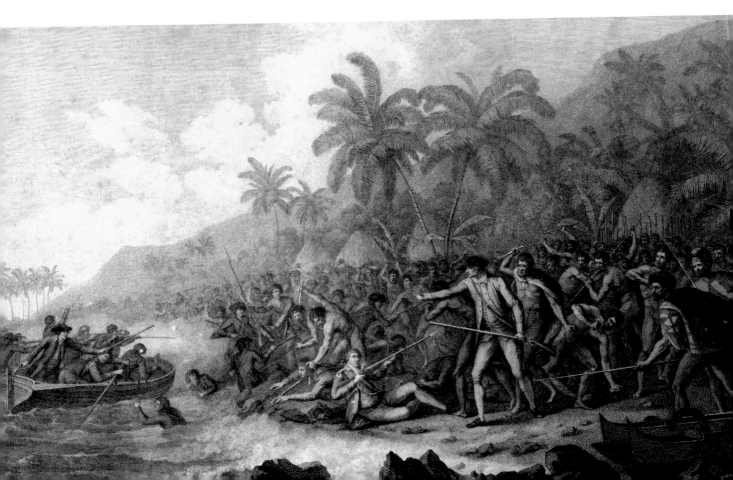

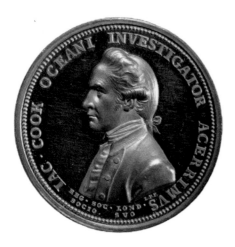

Medals to commemorate Cook were commissioned in 1780 by the
Royal Society, and were produced in gold, silver and bronze in 1784.
The design combined a uniformed bust of James Cook on one side with
the female figure of Fortune, standing on a globe and guiding a rudder on
the other. Cook was also included in a mural by James Barry, produced
for the Royal Society of Arts. At the forefront of the image, the explorer is
placed ahead of significant figures from the history of British navigation
such as Walter Raleigh (1552–1618) and Francis Drake (c. 1540–96).
Together they carry in a chariot the River Thames, depicted as a river god
and surrounded by figures representing global trade.

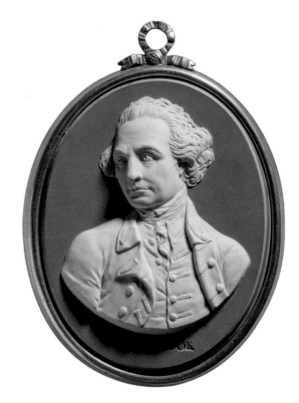

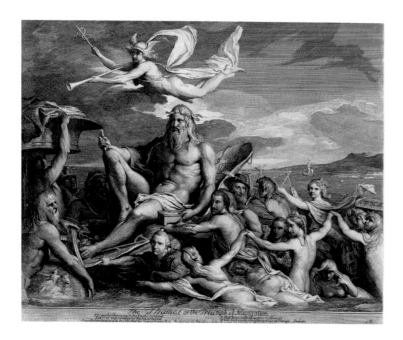

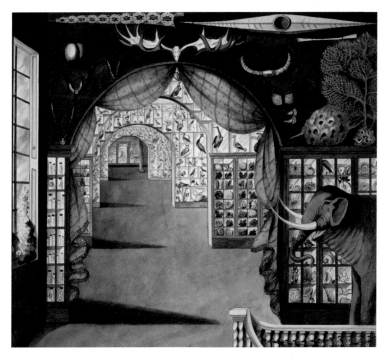

Museums played a role in the memorialization of Cook both during and after his lifetime, giving the public access to objects and information gathered on his voyages. The Leverian Museum, set up in Leicester Square in 1775, displayed objects collected by Cook and his crew in the Pacific and from 1787 onwards one of its rooms was dedicated 'to the immortal memory of Captain Cook'. In 1806 the contents of the museum were sold at auction.

Interior of the Leverian Museum
(view as it appeared in the 1780s)
After Sarah Stone, *c.* 1835
Watercolour on paper;
400 x 426 mm
The British Museum

A number of pantomimes about Cook were produced from the late eighteenth century, promoting a positive view of his voyages to a wider public. This print is based on a backdrop painted for the closing scene of the pantomime *Omai or A trip around the world*, first performed in 1785 in London's Covent Garden Theatre. It shows Cook being lifted to the heavens by Britannia and Fame, with his death depicted in the lower left-hand corner. He holds in his hands a sextant – a navigational instrument rather than a sword, or instrument of war.

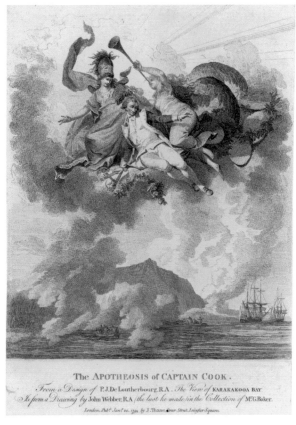

The Apotheosis of Captain Cook (right)
After Philip James de Loutherbourg and John
Webber, 1794
Etching on paper; 311 x 220 mm
The British Museum

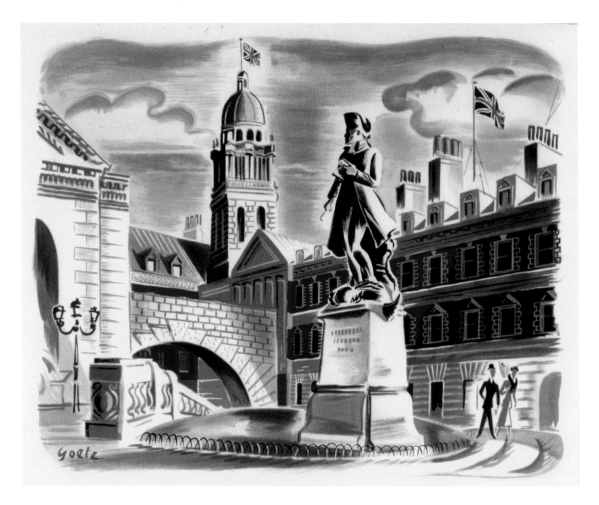

Statue of Captain Cook, The Mall
Walter Goetz (1911–95), 1937
Detail of a poster
The London Transport Museum

Cook has remained a fixture in the pantheon of British 'heroes' to this day. As recently as 2002 he came twelfth in a public vote to identify the '100 Greatest Britons'. There are twenty-six memorials to him in the UK, including plaques, busts and statues, many of which can be found in Yorkshire, where he was born. Other memorials can be found in London, including in Mile End, where he lived with his wife Elizabeth, and in Greenwich, where the Royal Naval College and National Maritime Museum are located.

Cook has also featured in advertising campaigns to promote travel to locations where he lived and worked. A London Transport poster from 1937, for example, depicts a bronze statue of Cook completed in 1914 by Thomas Brock (1847–1922). The statue is located on the south side of The Mall in Central London with Admiralty House and Admiralty Arch visible in the background. In the original poster, this image was placed above a depiction of Cecil Rhodes' House.

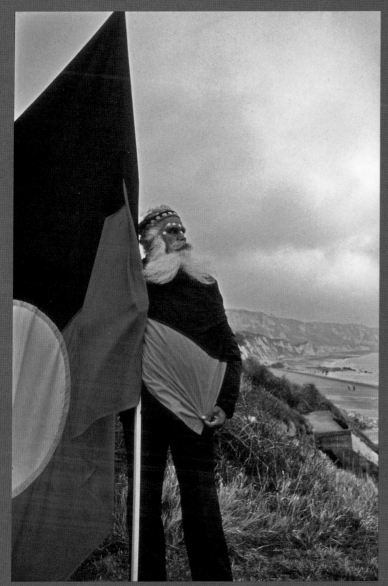

White Cliffs of Dover
Photograph, 2015

**Burnum Burnum planting
the Aboriginal flag at Dover**
Carmen Ky, 1988
Photograph

Burnum Burnum

On 'Australia Day' 1988, Aboriginal activist Burnum Burnum (originally
named Harry Penrith) 'landed' at Dover and raised the Aboriginal flag.
He declared England a colonial outpost of Australia, announcing that
'I, Burnum Burnum, a nobleman of ancient Australia, do hereby take
possession of England on behalf of the Aboriginal peoples…'. His act
mirrored the ceremony that Cook performed in Australia more than 200
years earlier, drawing attention to the complex legacies of such actions.

Reading list

Beaglehole, John Cawte,
The Exploration of the Pacific, 3rd ed., Black, 1966.

Beaglehole, John Cawte,
The Life of Captain James Cook,
Stanford University Press, 1974.

Brunt, Peter, et al.,
Art in Oceania: A New History,
Thames & Hudson, 2012.

Brunt, Peter, et al.,
Oceania,
Royal Academy of Arts, 2018.

Cook, James, ed. John Cawte Beaglehole,
*The Journals of Captain James Cook
on His Voyages of Discovery*,
Routledge, 2017.

Frame, William, and Walker, Laura,
James Cook: The Voyages,
British Library, 2018.

Grant, Stan,
Talking to My Country,
Scribe Publications, 2016.

McAleer, John, and Rigby, Nigel,
*Captain Cook and the Pacific: Art,
Exploration & Empire*,
Yale University Press, 2017.

Nugent, Maria,
Captain Cook Was Here,
Cambridge University Press, 2009.

Obeyesekere, Gananath,
*The Apotheosis of Captain Cook: European
Mythmaking in the Pacific*,
Princeton University Press, 1992.

Salmond, Anne,
*Two Worlds: First Meetings Between Maori and
Europeans 1642 – 1772*, Viking, 1993.

Salmond, Anne,
*The Trial of the Cannibal Dog: Captain Cook
in the South Seas*, Allen & Lane, 2003

Sculthorpe, Gaye, et al.,
Indigenous Australia: Enduring Civilisation,
The British Museum Press, 2015.

Smith, Bernard,
*Imagining the Pacific in the
Wake of the Cook Voyages*,
Melbourne University Press, 1992.

Thomas, Nicholas, et al.,
*Artefacts of Encounter: Cook's Voyages,
Colonial Collecting and Museum Histories*,
Otago University Press, 2016.

Thomas, Nicholas,
Discoveries: The Voyages of Captain Cook,
Penguin Books, 2018;

Thomas, Nicolas,
Oceanic Art, Thames & Hudson, 1995.

Picture credits